P9-ARD-667

WITHDRAWN

IMAGES
of America

WAKEFIELD

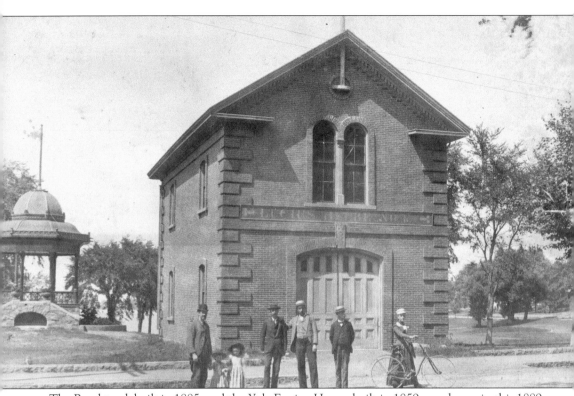

The Bandstand, built in 1885, and the Yale Engine House, built in 1859, are shown in this 1889 view of Wakefield Common.

IMAGES
of America

WAKEFIELD

Nancy Bertrand

ARCADIA

Copyright © 2000 by Nancy Bertrand.
ISBN 0-7385-0495-5

First printed in 2000.

Published by Arcadia Publishing,
an imprint of Tempus Publishing, Inc.
2 Cumberland Street
Charleston, SC 29401

Printed in Great Britain.

Library of Congress Catalog Card Number: 00-107740

For all general information contact Arcadia Publishing at:
Telephone 843-853-2070
Fax 843-853-0044
E-Mail sales@arcadiapublishing.com

For customer service and orders:
Toll-Free 1-888-313-2665

Visit us on the internet at http://www.arcadiapublishing.com

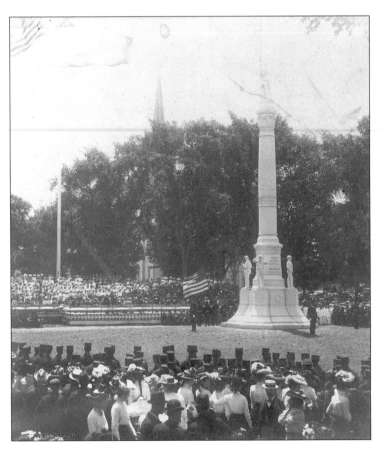

The dedication of the Soldiers and Sailors Memorial took place in 1902. The monument was made possible by Harriet N. Flint, who donated $10,000 for that purpose. The dedication by Governor Crane was held on June 17, with town officials and officers of the Grand Army of the Republic present. Five hundred public school children sang patriotic songs for the occasion.

CONTENTS

Introduction 7

1. A Village by the Pond 9

2. Our Illustrious Fellow Citizen 35

3. An Enterprising Community 49

4. A New Century 89

5. School Days 105

6. Fire! 121

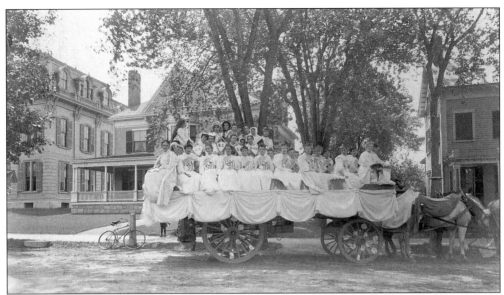

The Wakefield High School float in the 1894 parade is adorned by the high school coeds. Mrs. Hubbard Mansfield, one of the girls on the float, recalled many years later, "The float portrayed the various states in the union, the four seasons and Columbia. I was Columbia—probably because I had the most hair—and it caught in the branches while I called out in vain from where the driver couldn't hear me. And such a sunburn!" In the background, at the left, is the Lafayette Building (the old high school).

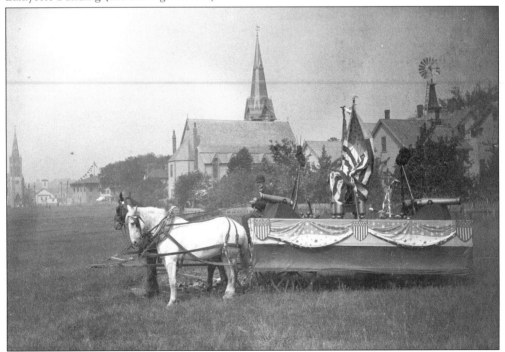

The float of the Grand Army of the Republic waits to join the parade to celebrate the town's 250th anniversary in 1894. The float is located on Richardson Avenue. St. Joseph's Church is at the left; the Methodist church on Albion Street is in the center.

INTRODUCTION

For more than 10,000 years, the land we now call Wakefield was inhabited by Native Americans. Our two lakes were remnants of a larger lake system that served as spawning grounds for fish 8,000 years ago. The native people who lived here hunted deer and other large animals; they gathered wild foods and grew crops of corn, beans, and squash. Our recorded history begins with the European settlements in the 17th century. Only 19 years after the landing of the Pilgrims at Plymouth, in 1639, a small band of colonists from Lynn successfully petitioned the legislature for "an inland plantation," which would be named Linn Village. In 1644, when seven families had settled and seven houses had been built, the court ordered that the town might be incorporated. At that time, the village, located near the shores of the "Great Pond" (Lake Quannapowitt), took the name of Redding.

It was a community of farmers, taking advantage of the enormous flocks of wild pigeons, wild turkeys "exceeding fat, sweet and in abundance, fish in the rivers and ponds, grapes, blackberries, blueberries in great quantities." By 1667, the community, including what is now known as Reading and North Reading, boasted 59 houses. A garrison house was built against Native American attacks in 1671. In 1686, the settlers bought their land from the Saugus Indians.

The town sent its share of men to the Revolutionary War, but no battle was fought within its bounds. When the Declaration of Independence was first read publicly, it was unanimously voted to "adhere to its sentiments and stand by it to the last." The town lived up to that pledge, sending men and supplies as needed, and quartering British prisoners of war. By the conflict's conclusion, between 400 to 500 men—approximately one-quarter of the population of Redding—had served their fledgling nation in the conflict that had resulted in its birth.

By the late 18th century, the town was essentially split into three separate and distinct parishes: the First Parish (Wakefield), the Second Parish (North Reading) and the Third Parish (Reading). Although the First Parish was the oldest section, and the largest, the combined votes of the other two parishes was greater. Consequently, the Federalist majority in the Second and Third Parishes consistently outvoted the staunch Democratic Republicans in the First Parish, effectively, as they thought, denying them representation in the legislature. As early as 1785, the First Parish petitioned to be set off as a separate town. Issues came to a head just before the War of 1812, and the Massachusetts legislature finally granted their petition in 1811. The town of South Reading was formed in 1812.

At the time of its incorporation, South Reading was still a rural, isolated hamlet with no regular stage transportation. The population numbered around 800, with about 125 residences standing on 16 public roads. The new town grew slowly but steadily; by 1832, it would be

described as a farm town with "163 dwelling houses, 110 barns, 3 Grist Mills, 3 Saw Mills, 106 Horses, 58 Oxen, 275 Cows, 18 Steers and Heifers, 8 Sheep . . . 191 Hogs" and 1,311 inhabitants.

The town now boasted a Temperance Society and the Franklin Lyceum. An Anti-Slavery Society was formed; the Franklin Library began its existence; the South Reading Ornamental Tree Society formed to preserve the shade trees in town. Four hundred children attended school in four district schoolhouses; a Baptist Society had founded the South Reading Academy for higher education. The biggest change, however, was wrought by the Boston and Maine Railroad, which would run its line through the town in 1845. The change it caused was dramatic, doubling the population from 1,600 to 3,200 in 15 years.

The railroad would transform South Reading from a sleepy little farm town north of Boston to a suburb of the big city. The new train service spurred the growth of the old East Ward, already calling itself Montrose, and encouraged day trips by Boston residents to picnic "groves" and summer camps in the healthy air of Greenwood.

The quick rail service had given new impetus to old businesses, such as the shoe manufacturing industry. New ones, such as the ice industry, using ice harvested from the town's two lakes, were soon established. In 1851, an entrepreneur named Cyrus Wakefield came to town, establishing two new industries: the Boston and Maine Foundry and the phenomenally successful Wakefield Rattan Company, which popularized the use of wicker in the United States. (This company later merged with Heywood Brothers of Gardner, Massachusetts, to become the Heywood-Wakefield Company.) The success of these ventures changed the character of South Reading to a manufacturing center within a comfortable commuting distance of Boston. In 1868, after Cyrus Wakefield offered to donate a new town hall, the town of South Reading voted to change its name to Wakefield, Massachusetts.

As Wakefield approached the 20th century, it continued to grow and flourish. Two major boosts were given to the town's economy with the coming of the Miller Piano Factory and the Winship Boit Company (Harvard Knitting Mills) in 1889. Gas for lighting streets and houses was introduced by the Citizen's Gas Light Company in 1860. Telephone service was achieved in 1894 and water service in 1883.

During the 20th century, the suburban character of the town became firmly established. The town's location on route 128 has recently attracted a proliferation of high-tech industries. But as Wakefield rushes to embrace the future in the 21st century, it also works to preserve its past. A rich resource of historical documents and resources is present in the files of the Wakefield Historical Society. In writing this volume, I have drawn again and again on previously published works, such as the 1872 *Genealogical History of Wakefield, Reading and North Reading* of Lilley Eaton and the anniversary histories published in 1894, 1944 and 1994. I have also drawn on notes and manuscripts of the late William E. Eaton and Ruth Woodbury. This volume will offer readers a brief glimpse at the history of Wakefield; for a comprehensive look, they are urged to read the town's 350th anniversary history, *Wakefield: 350 Years by the Lake*, published in 1994 by Wakefield 350.

Wakefield is fortunate to have a number of organizations all working to preserve and protect its historical legacy; aside from the Wakefield Historical Society, the Col. James Hartshorne House Association works to preserve the c. 1681 historic house. The Americal Civic Center Association cares for the old state armory. The town's biggest preservation challenge, however, is the West Ward School, an 1847 schoolhouse. The schoolhouse, damaged by structural problems in the 1990s, is currently undergoing an active restoration and preservation effort by the West Ward School Association. The ultimate goal is to restore the school building as a living history schoolhouse, which will continue the school in its historic function as an educator of Wakefield's children. Royalties derived from the publication of this volume will help to make the dream of a restored West Ward School a reality.

—Nancy Bertrand
July 31, 2000

One

A VILLAGE BY THE POND

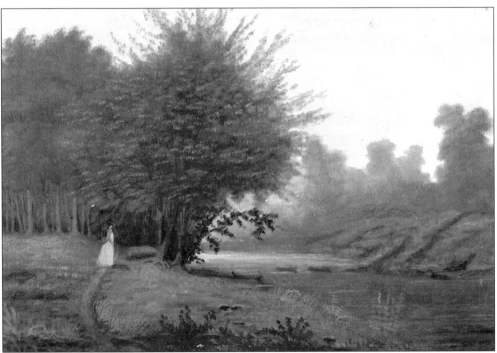

In 1639, settlers from nearby Lynn sought permission to use a plot of land "at the head of their bounds," stating that a more desirable land lay there, with two beautiful lakes, two rushing rivers, and a valley of fertile soil and forests. It was a "pleasing prospect to those anxious expectant men and their families." A traveler named Josselyn found the town "in the center of the country, by a great pond side" with two mills and well stocked with cattle. The painting shown above is an untitled work by the Wakefield artist Franklin Poole.

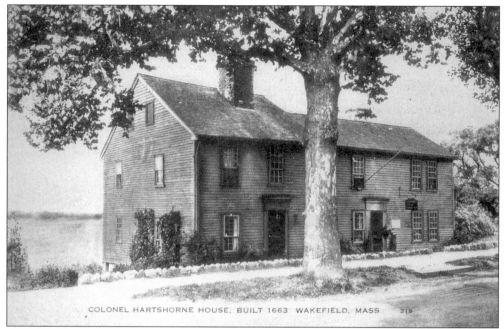

COLONEL HARTSHORNE HOUSE, BUILT 1663 WAKEFIELD, MASS.

One of the oldest houses still standing in the town of Wakefield is the Hartshorne House, a portion of which was built prior to 1681. The house was built by Mary Hodgman and her husband, Thomas. Mary had inherited the money that paid for the house from her first husband, Ezekial Morrill. Following the Hodgmans' tenancy, the house was owned by clockmaker Nathaniel Cowdrey and by Dr. John Hart, who transformed the second floor into a Masonic lodge. The house was occupied from 1803 to 1870 by Col. James Hartshorne and his family.

The Rev. Samuel Haugh house, built prior to 1662, stood at the intersection of the present Main and Water Streets. The house was later occupied by Noah Smith; it was moved to 15 Lincoln Street in 1868 to make room for the Cyrus Wakefield Town Hall and remained standing until the 1950s.

The first meetinghouse of the community was built approximately on the corner of Main and Albion Streets. This view shows a speculative drawing of the second meetinghouse, built in the approximate location of the current First Parish Congregational Church, the lineal descendant of that first meetinghouse. The town, which then encompassed the towns of Wakefield, Reading, and North Reading, took the name Redding. The first settlers in the new community stayed in what is now Wakefield (First Parish). No settlement was made in "the Woodend" (present-day Reading) until 1666.

This view shows the 17th-century record books of the first congregation. In this Puritan settlement, there was no separation of church and state. These books are our best source of information about the early town. The books are the possession of the First Parish Congregational Church.

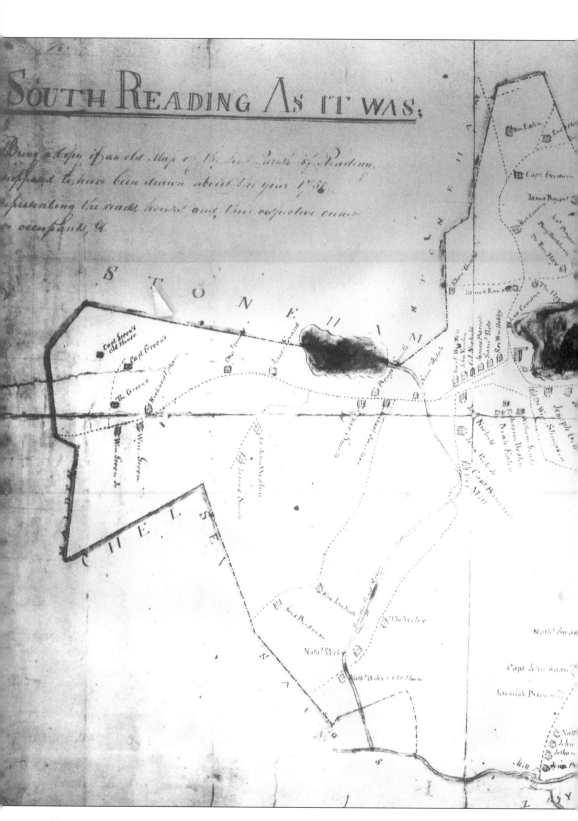

SOUTH READING As it was;

Being a Copy of an old Map of the first Parish of Reading, supposed to have been drawn about the year 175_, representing the roads, houses and their respective owners or occupants, &c.

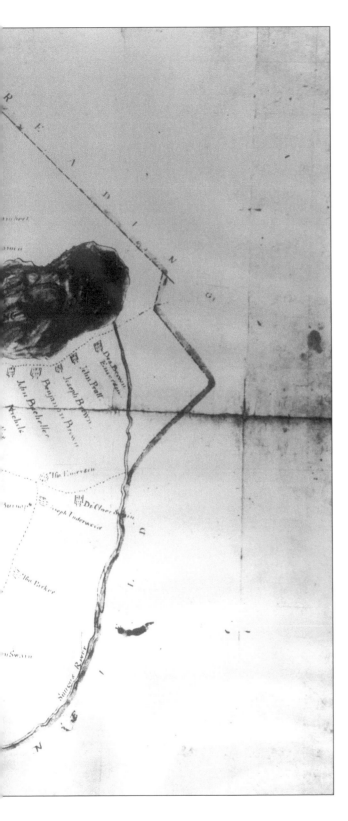

This very early map shows the portion of the ancient town of Reading (encompassing Wakefield, Reading, and North Reading) that corresponds to the present-day Wakefield. The text reads, "South Reading As It Was: Being a Copy of an old Map of the First Parish of Reading supposed to have been drawn about the year 1759, representing the roads, houses and their respective owners or occupants."

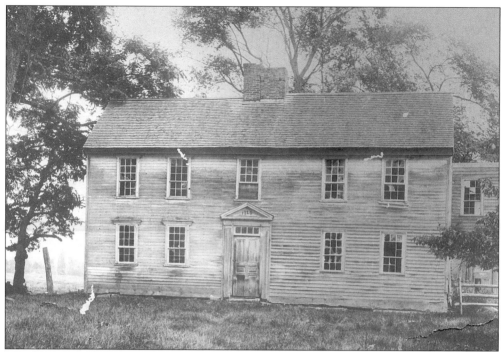

This house was erected by Dr. Thomas Swain and was long occupied by the Swain family, one of the oldest families in town. It stood on the east side of Vernon Street north of Lowell Street, but burned down in 1899.

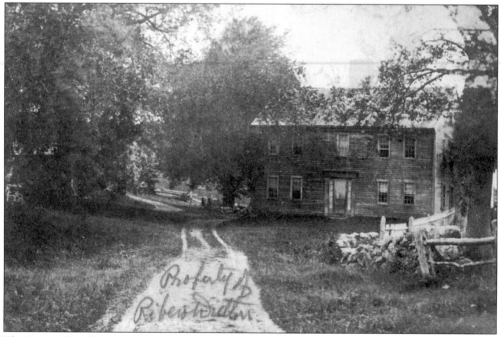

The Ensign Hopkins Homestead, which stood at one time on the north side of Hopkins Street at the foot of the hill, was probably built c. 1722 by Joseph Bancroft, who had married Ruth Parker, the granddaughter of the land's original owner.

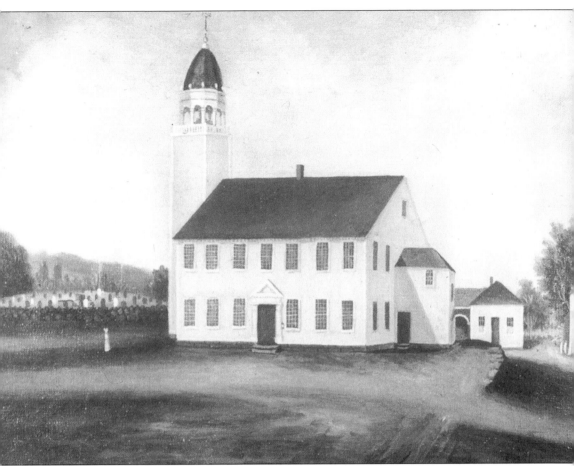

This third meetinghouse of the First Parish of the town of Reading stood in the approximate location of the present First Parish Congregational Church. The 1767 construction of this building was a very controversial action since the people of the First Parish (Wakefield) expected the people of Woodend (Reading) to assist in its cost. The matter eventually ended in the General Court, which forced a refund of the Woodend share. Woodend established itself as the new third parish of the town. The animosity engendered here grew until the First Parish split off from the town of Reading, establishing itself as the Town of South Reading in 1812. This church building, unpainted for years, was extensively remodeled in 1837 and 1859, and would be taken down in 1890 for a new church building. The painting shown above was done by Wakefield artist Franklin Poole.

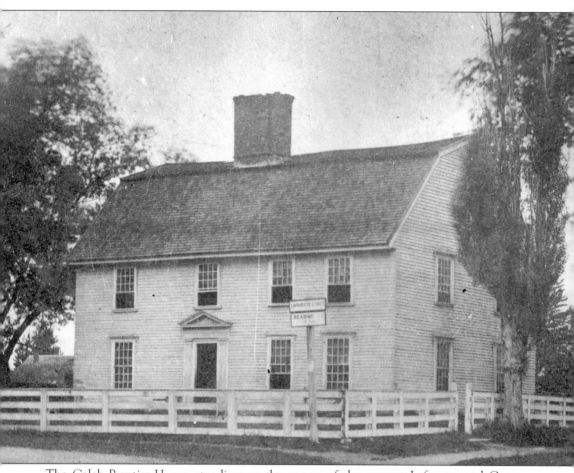

The Caleb Prentiss House, standing on the corner of the present Lafayette and Common Streets, was built c. 1740 and was removed to Traverse Street in 1870 to make room for the new high school building (now the Town Hall). It later burned to the ground. Caleb Prentiss was the minister of the Congregational Church during the Revolutionary War. He was described as a Revolutionary Whig and a patriot and was among those who answered the "alarum" after the "shot heard round the world."

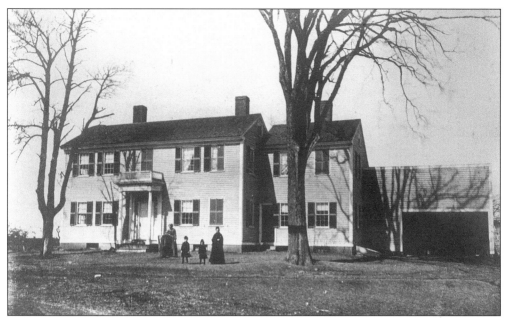

Maj. Suell Winn built this house on Elm Street *c.* 1813. Major Winn was known for his industry, honesty, and sterling character. In 1844, his extensive farmlands were divided by the railroad. Upset at this development, Major Winn rose up at town meeting to speak vehemently for the need to erect a safeguard at the crossing near his home. On the way home, he was killed by a train trying to cross at that very spot.

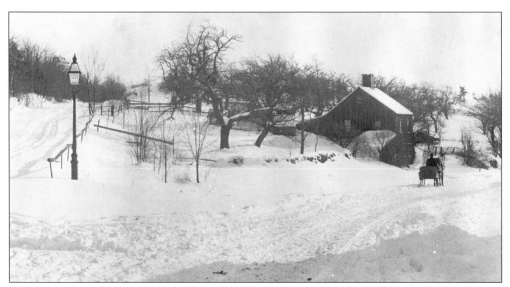

A carriage travels to Greenwood in this late-19th-century view. The land that is now encompassed by Greenwood was originally part of Charlestown and was later part of Malden. It was joined to the town of Reading in 1729. The old Green House, located on the easterly side of Main Street, was built *c.* 1754. Note the streetlight in the foreground.

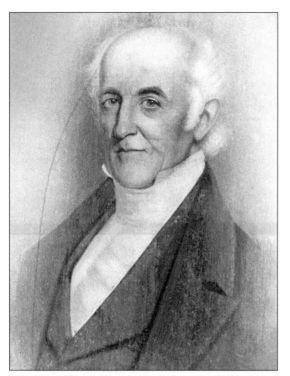

The town's largest employer in the early 19th century was Burrage Yale, shown here in a painting from the collection of the Wakefield Historical Society. Born in Meriden, Connecticut, folk tradition tells us that he arrived in South Reading walking down Cowdrey's Hill, barefoot, with his team and wagon and assortment of tinware to sell. He decided to make his fortune in the town and married the daughter of the gentleman who had given him lodgings on his first night in town.

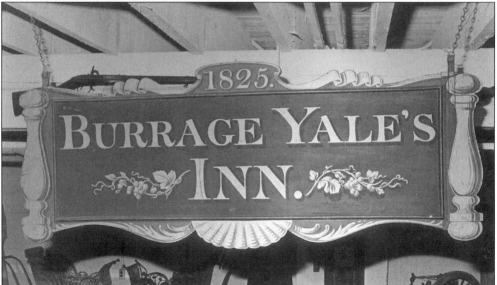

The fanciful signboard from the inn owned by Burrage Yale is now in the collection of the Wakefield Historical Society. Burrage Yale's fortune was made in tinware. His factory stood on the corner of Lafayette and Main Streets, and he employed more than 100 people from the village in his tin shop and many others in his tavern and general store. He contributed mightily to the purchase of a fire engine, which was named "the Yale" in his honor. Nonetheless, he never became very well liked in the town and was on one occasion to be seen hanging in effigy from one of the old oaks on the Common. The effigy was thence consumed in a great funeral pyre to the approving shouts of the crowd.

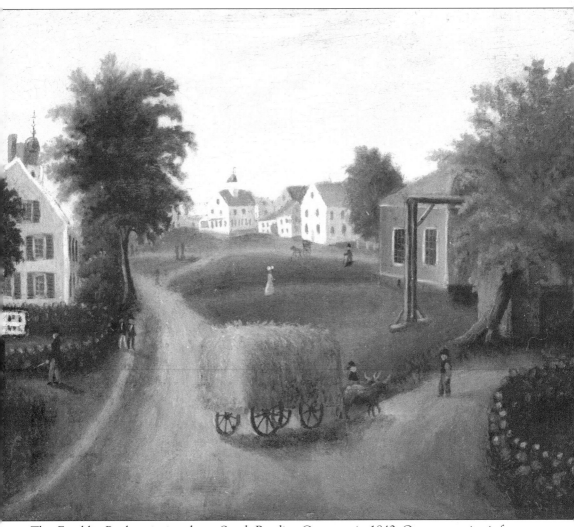

This Franklin Poole painting shows South Reading Common in 1840. Our perspective is from Main Street just east of the present Lower Common. The street to the left is Salem Street; to the right are the town's hayscales and the old Center Schoolhouse. Down the street to the right are the Caleb Prentiss House, the Hale Tavern, and the tin shop of Burrage Yale in the distance.

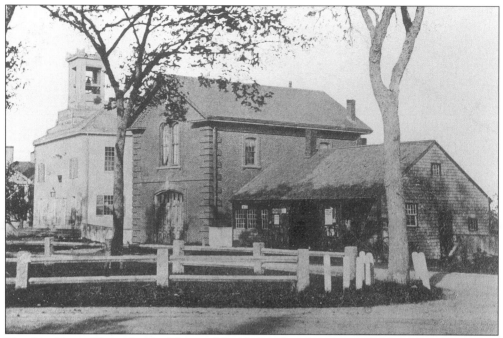

The first Town House for the Town of South Reading (now Wakefield) was built in 1834. Although the town had formally split off from Reading in 1812, the town's business was conducted at the First Parish Church (page 15) for 22 years. The Town House was also a school building, housing two classes of elementary school students. Shown in this 1860s photograph is the Town House (the building with the cupola), the Yale Engine House, and the blacksmith shop. These structures stand on the town's original burying ground.

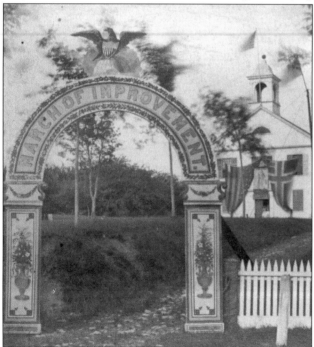

The town's celebration of its 200th anniversary in 1844 was the occasion of great rejoicing. In this stereoscopic view, the South Reading Academy is shown through an arch. The South Reading Academy, established in 1829 and funded by private subscription, was an introductory school to the theological seminary for the Baptist ministry, although it was open to all.

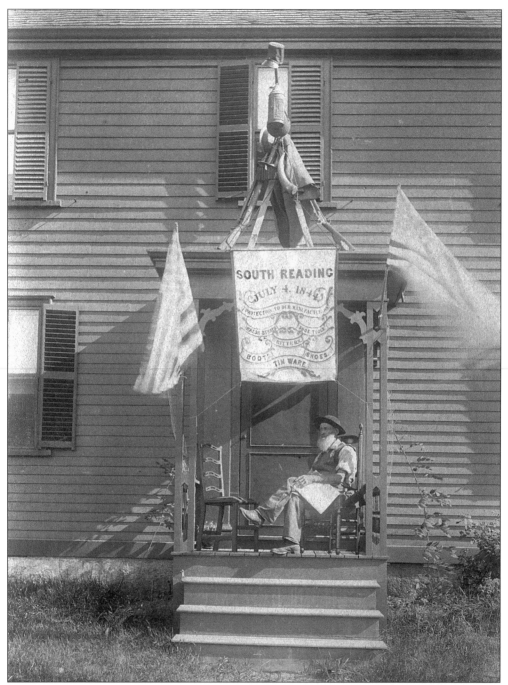

John Rayner celebrates the Fourth of July in 1889 under a banner carried in the parade celebrating the town's 100th birthday in 1844. The banner reads, "Protection to our manufacturers: razor straps, shoe tools, bitters, boots, shoes and tinware." The muskets and powder horn were said to have been used in the Revolutionary War. The lantern was reputed to have been one of those hung in the Old North Church on the night of April 18, 1775, as Paul Revere's signal to "Ride and spread the alarm / Through every Middlesex village and farm."

Most early-19th-century South Reading families were either employed as shoemakers or engaged in shoe making as a side occupation during the winter months. Many, in fact, had shoe shops in the backyard. This photograph shows the barn and shoe shop of Moses Boardman at the head of Pearl Street, where 56 Pleasant Street now stands. Edward Walton and his son, Charles E. Walton, rented the shop for the manufacture of handmade shoes from *c.* 1885 to 1895.

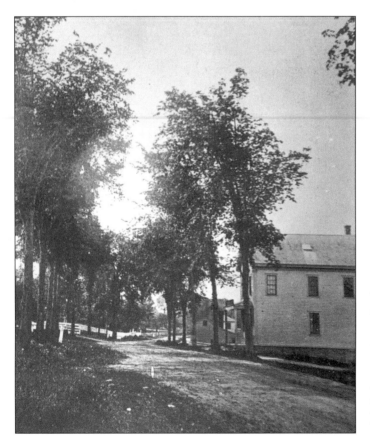

The J.G. Aborn and Company shoe manufacturing concern, operated by Henry Haskell Jr., maintained this shoe shop on Main Street during the 19th century. Behind the white shoe shop (right) is Lake Quannapowitt.

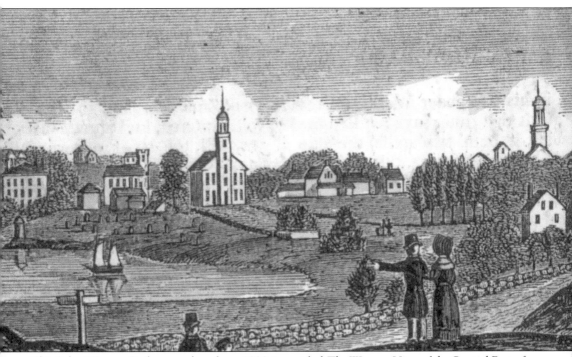

This John Warner Barber woodcut from 1839 is entitled *The Western View of the Central Part of South Reading*. Barber writes of the town, "The territorial extent of this town being quite limited, and most of the inhabitants being engaged in manufactures, very little attention is paid to agriculture; the great staple and settled business of the town is the manufacture of ladies' shoes." The population at that time was 1,488.

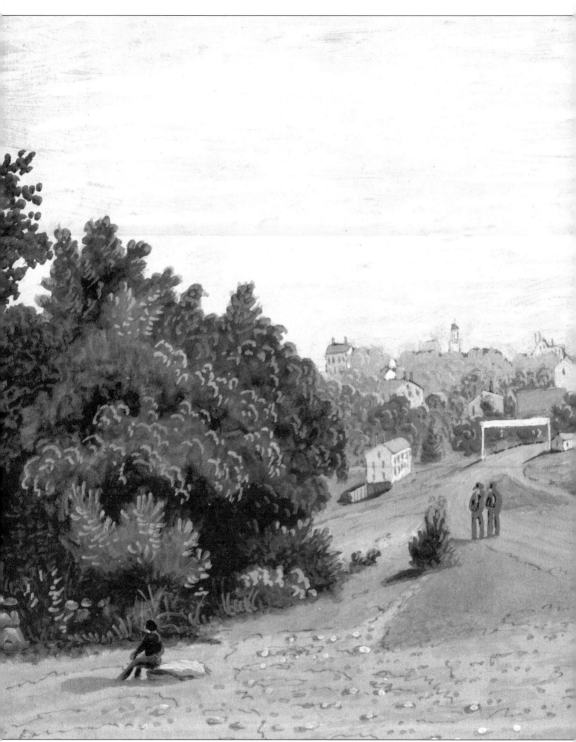

This painting by Franklin Poole shows what is now called Prospect Street. The view looks down the hill toward the railroad crossing, known to the residents as "Deadman's Crossing." The sign at the crossing reads, "Look out for the Engine." The three houses (including 22 and 24

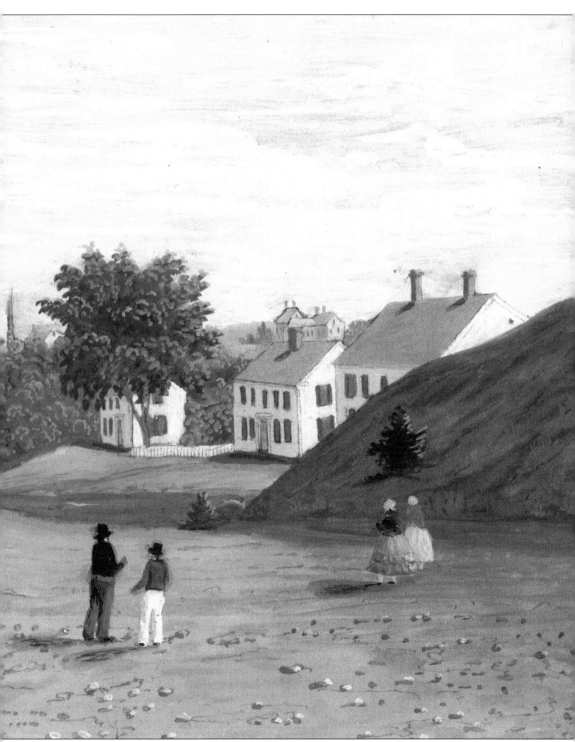

Prospect Street) on the right were known as the Atwell homes. Joseph Atwell produced razor straps, a locally important industry. The West Ward School, one of four schools built in 1847 to serve the growing population of the town, would have been up the hill to the left.

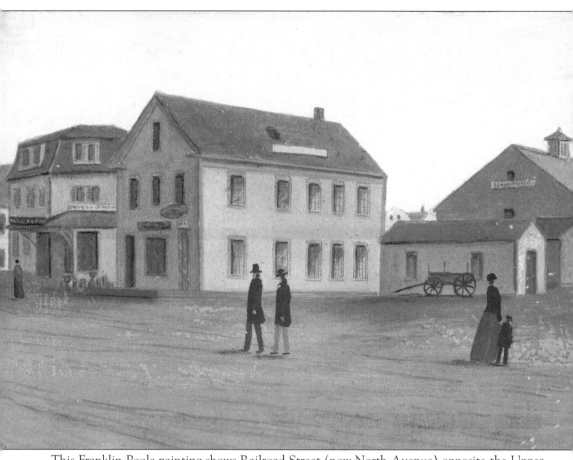

This Franklin Poole painting shows Railroad Street (now North Avenue) opposite the Upper Station. The coming of the railroad had an enormous influence on the town, doubling its growth during a ten-year period in the 1840s. The railroad allowed local manufacturers to gain quick and inexpensive access to raw materials and to find new markets for their products.

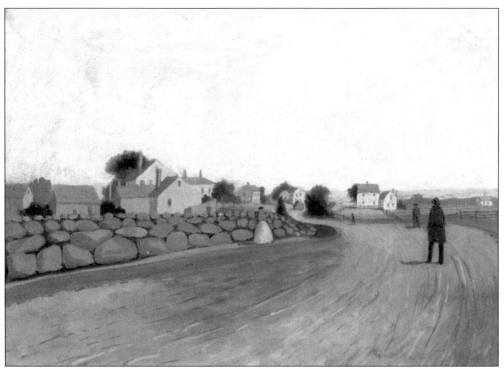

The South Reading Branch Railroad Station in Montrose, painted by Franklin Poole, shows Salem Street looking to the east, near Montrose Avenue. The houses centered around the Hawkes Flannel Factory, or fulling mill, on the Saugus River, the station and a quarry over the Lynnfield line.

The artist Franklin Poole was born in 1808. In his 90-year life, he chronicled the town's growth in his paintings.

The Eaton Homestead was one of the most important local landmarks through the early 19th century. It was not only the most popular general store, it also functioned as the post office. The house was built in 1804 and was demolished in 1913. It stood on the north corner of Main and Salem Streets.

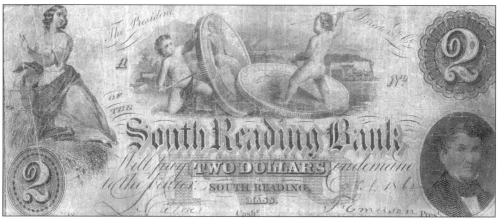

This bank note from the South Reading Bank lets the bearer know that "the President, Directors and Co. of the South Reading Bank will pay two dollars on demand to the Bearer." The note shows the likeness of the bank president, Thomas Emerson, and is hand signed by him.

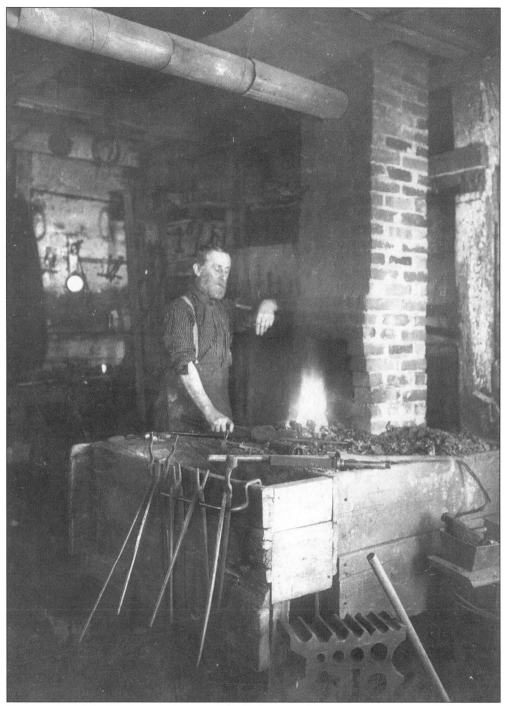

The interior of the blacksmith shop on Church Street is shown in this photograph. Pictured is John Minniken.

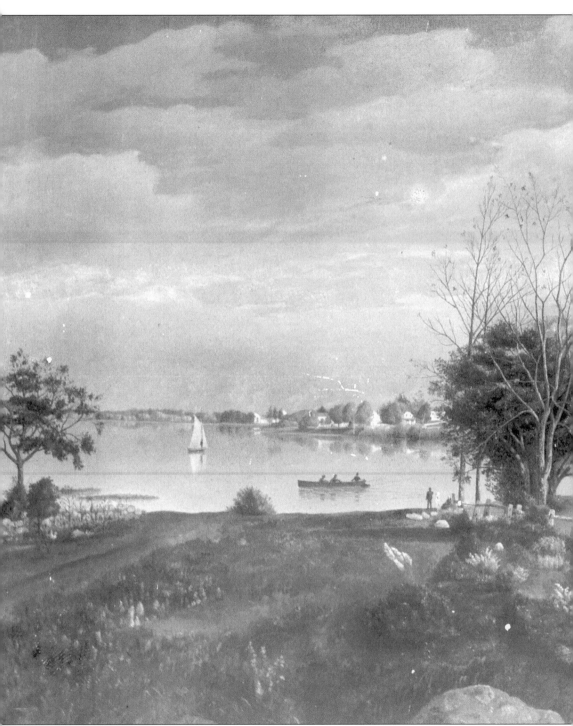

The painting *Pond Lane* shows Lake Quannapowitt from the approximate location of the Lower Common. This painting shows the larger houses beginning to be built at lakeside. During the 1840s, the town laid out many new streets and formalized names of lanes and streets. South Reading Pond was renamed Lake Quannapowitt in honor of James Quonopohit, one of the

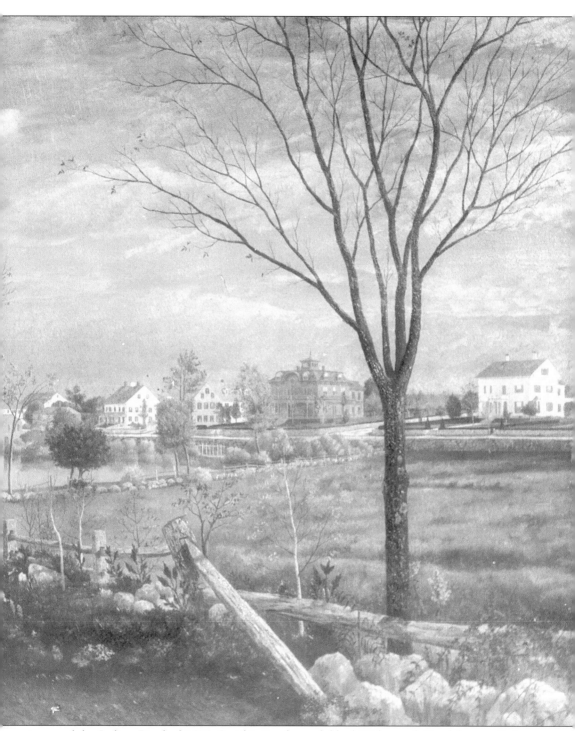

signers of the Indian Deed of 1686. Smith's Pond was dubbed Wahpatuck Pond (now called Crystal Lake). This view, painted by an unknown artist, presumed to be Henry Cheever Pratt, shows the area between 1860 and 1880.

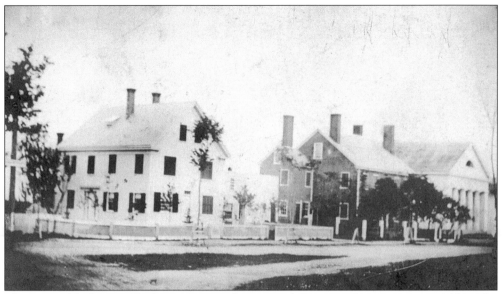

This very old photograph shows corner of Main and Crescent Streets prior to 1850. The building to the far right is the Universalist Unitarian church, which was originally built to resemble a Greek temple in 1839. It was remodeled and had a steeple attached in 1859.

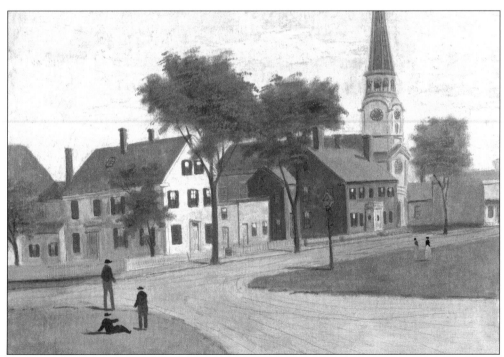

Franklin Poole's painting of this same area, done between 1860 and 1883, shows the artist's attention to detail. His almost photographic rendering of 19th-century scenes has left an enormous legacy to town historians. The buildings shown, from left to right, are the Benjamin Wiley house (built before 1810), the Wiley-Batchelder brick house (built in 1822), and the remodeled Universalist church.

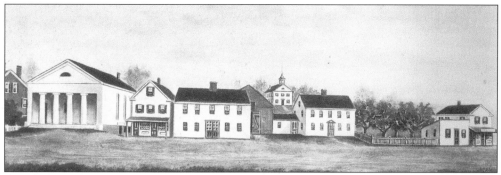

This rendering by early-20th-century artist Joseph Payro shows the east side of Main Street in 1858. From left to right are the Universalist church, the Harry Knowles house, a dry goods and grocery store, the home of John Rayner, and the home of Edward Mansfield. Joseph Payro was a photographer of great note and had an avid interest in the history of his town. He was employed by the Heywood-Wakefield Company. His original art detailing many of the plant's designs is in the possession of the Beebe Memorial Library.

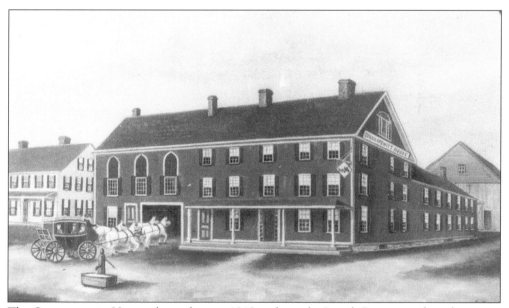

The Quannapowitt House, shown here c. 1840 as drawn by Joseph Payro, stood on the corner of Albion Street and Main Street. The hall was built as an addition to the house of Samuel Wiley. The house itself was later moved to the corner of Avon and Railroad Street (North Avenue). The hall was moved up Albion Street and used as a billiard and refreshment saloon until it was sold to the Methodist Society.

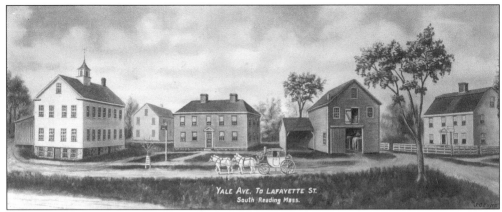

This Joseph Payro rendering of the west side of Main Street between Lafayette and Yale Avenue in the 1850s shows, from left to right, the tin shop of Burrage Yale, the Hale Tavern, and the Caleb Prentiss House. The Hale Tavern contained the most spacious hall in the village. According to 19th-century historian Lilley Eaton, it was "the place for dancing and singing schools, for Masonic lodge meetings, for public dinners, caucuses, puppet-shows, etc." The hall was taken down in 1865 to make room for the Baptist church.

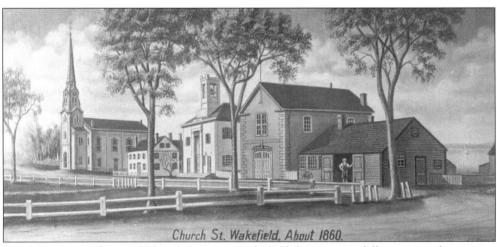

Joseph Payro's rendering of Church Street in Wakefield shows a very different view than is seen by contemporary visitors to the area. At the far left is the First Parish Congregational Church after being remodeled and reoriented, along with its parish hall, the Town House, the Yale Engine House, and the blacksmith shop, with the lake in the background.

Two

OUR ILLUSTRIOUS FELLOW CITIZEN

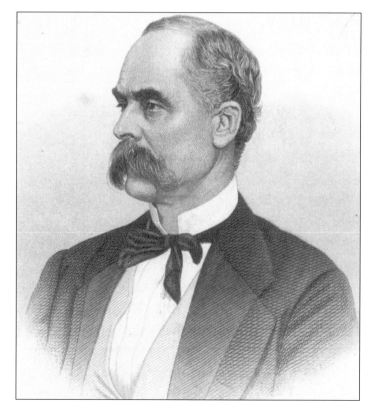

In 1855, a businessman born in Roxbury, New Hampshire, relocated his growing rattan and wicker business from Boston to the town of South Reading. Cyrus Wakefield, born on February 14, 1811, would have an enormous impact on his adopted town of South Reading, Massachusetts—so much so that in 1868 the town voted to rename itself in his honor.

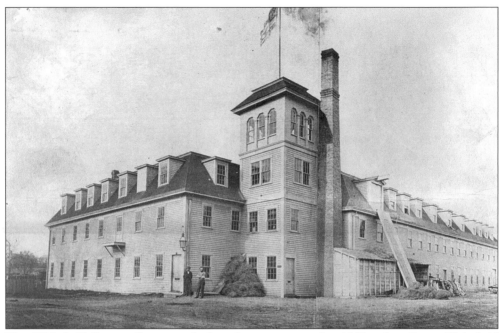

The Wakefield Rattan Company had its beginnings in the 1830s after Cyrus Wakefield accidentally purchased a small lot of rattan abandoned on a Boston dock by a sailing ship that had used it as packing material on its trip across the South Pacific. After its factory was established in South Reading in 1855, the company began by making hoop skirts and baskets and gradually began making furniture.

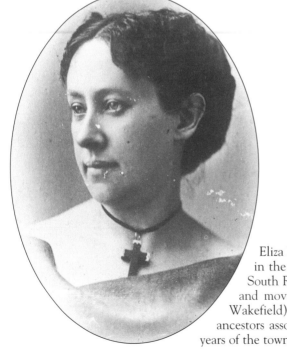

Eliza Bancroft Wakefield met Cyrus Wakefield in the 1830s while his sister was attending the South Reading Academy. They married in 1841 and moved their home to South Reading (now Wakefield) in 1851. Both Eliza and Cyrus had ancestors associated with South Reading in the early years of the town. The couple had no children.

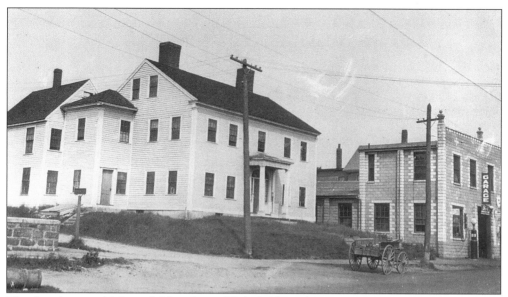

The first home of Mr. and Mrs. Cyrus Wakefield in the town of South Reading was this comparatively modest structure on the northern corner of Main and Armory Streets.

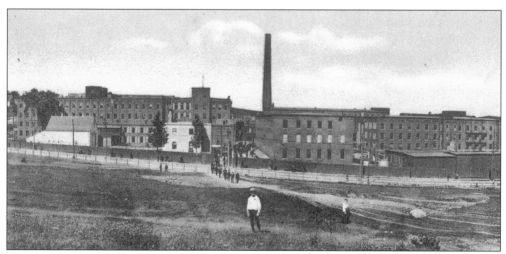

By 1876, the Wakefield Rattan Company had grown to include 19 buildings, valued at over $100,000. The company employed more than 1,000 people. This view shows the company in the early 20th century.

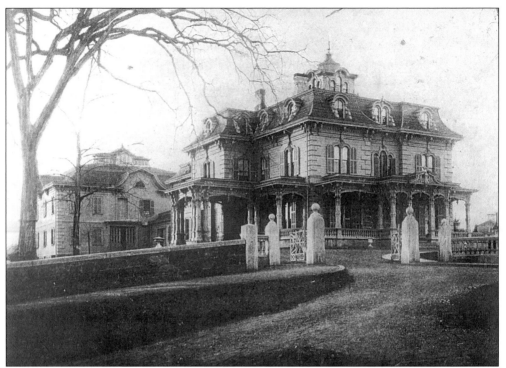

The palatial 1863 estate of Mr. and Mrs. Cyrus Wakefield, built 12 years after the couple's move to town, was designed in the Italianate style by an architect named Copeland.

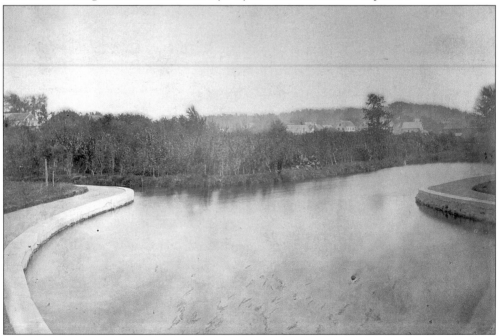

The estate, located on the present site of the Galvin Middle School, encompassed the enormous house with a barn of a comparable size, a summerhouse, orchards, canals, and greenhouses. This view shows the yard of the property, now the Walton Field.

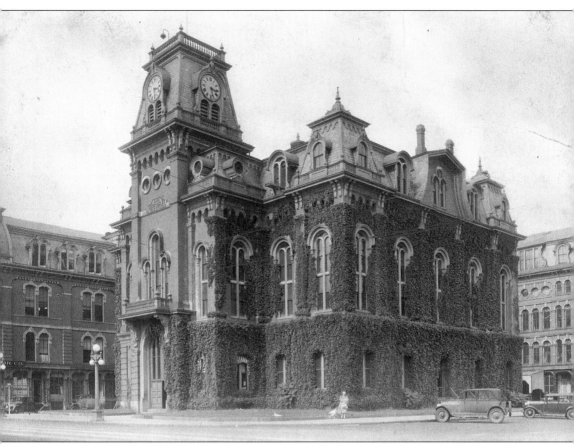

In 1868, Cyrus Wakefield offered to donate a new town hall to South Reading. In gratitude, the town voted to change its name from South Reading to Wakefield, Massachusetts. The donor hired an architect to design the building. After its completion, it was sold to the town for the sum of $1. The structure was dedicated on February 22, 1871.

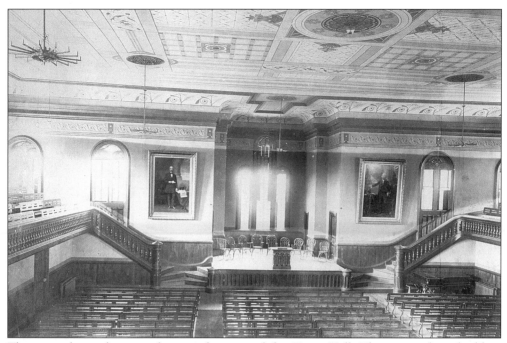

This view shows the magnificent auditorium of the Town Hall. The commodious building housed all town offices, including the library (with books donated by Lucius Beebe) and the police station. The furnishings of the building had been donated by Solon O. Richardson.

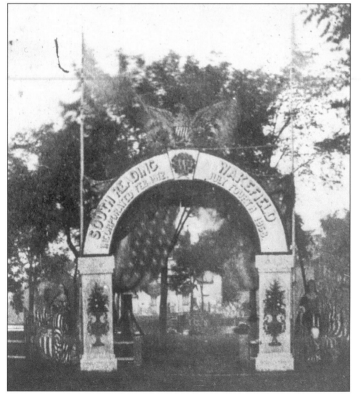

The town had an enormous celebration in honor of the change of its name to Wakefield in 1868. Shown here is a painted arch at the entrance to the Common, where a "'Mammoth Tent' in which the dinner was served, covered sufficient space to accommodate, at table, two thousand guests; and a dinner, furnished by Mr. A.A. Currier as caterer, proved to be an ample, satisfying, and enjoyable entertainment to its thousand participants."

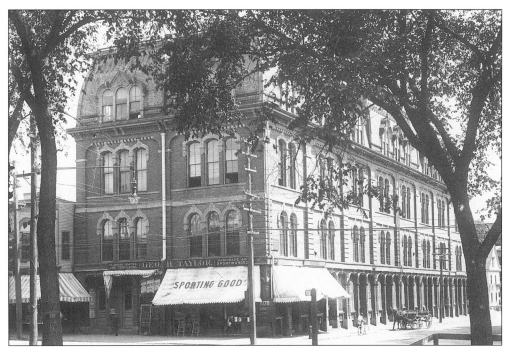

Cyrus Wakefield's munificence to the town that bore his name did not stop at the $100,000 gift of the Town Hall. He was determined to bring prosperity to the town and constructed fine new buildings, such as the Taylor Building (shown), which was built in 1870. In addition, he was on the board of numerous organizations and businesses: the Wakefield Savings Bank, the National Bank of South Reading, the Citizens Gas and Light Company, the town library, and others.

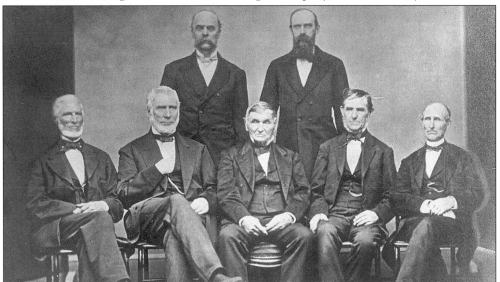

This 1860s photograph of the luminaries of the town shows the directors of the South Reading Bank (probably after its reorganization in 1865). Shown, from left to right, are the following: (front row) Samuel Gardner, Lucius Beebe, Thomas Emerson (president), Lilley Eaton (cashier and the town's first historian), and Edward Mansfield; (back row) Cyrus Wakefield and George O. Carpenter.

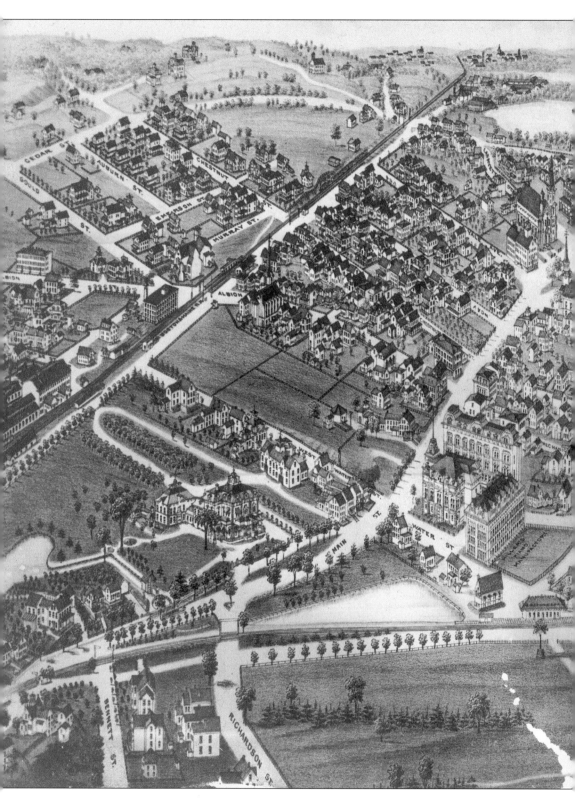

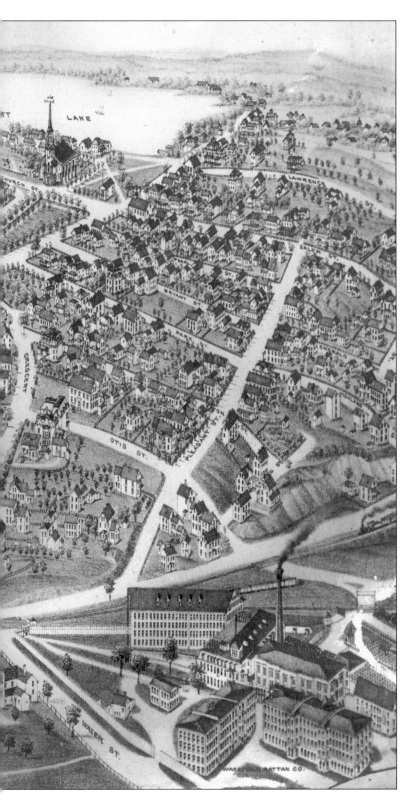

This advertising caricature map, published in 1882, shows the impact that Cyrus Wakefield had on his adopted town. Excluding churches, most of the large buildings shown had some connection with Cyrus Wakefield.

43

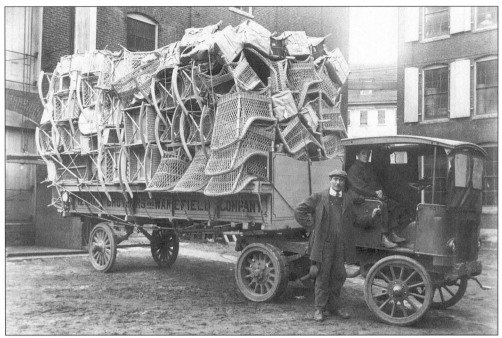

In 1897, the Wakefield Rattan Company merged with the Heywood Brothers of Gardner, Massachusetts, to form the Heywood-Wakefield Company. This 1919 view shows a company truck loaded with 219 rattan chairs ready for delivery.

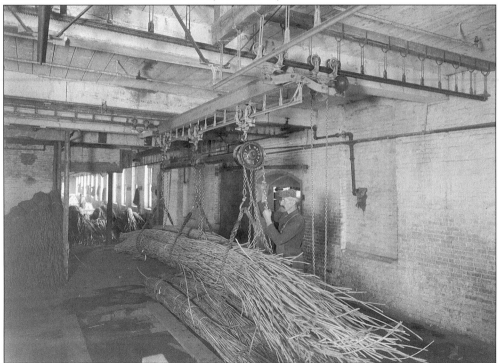

This view inside the rattan plant shows Heywood-Wakefield worker Bartholomew Cline with the raw material for the plant.

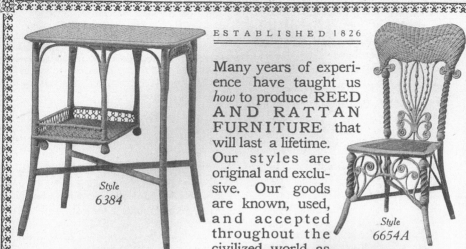

ESTABLISHED 1826

Many years of experience have taught us *how* to produce REED AND RATTAN FURNITURE that will last a lifetime. Our styles are original and exclusive. Our goods are known, used, and accepted throughout the civilized world as

Style 6384

Style 6654A

the standard of excellence. For *strength, lightness,* and *beauty of finish* they have *no equal,* but like all good things are imitated.

Heywood-Wakefield
TRADE MARK

————FACSIMILE OF OUR TAG————

ASK YOUR DEALER to show you our goods bearing the little white tag as shown above. If he does not carry our line, do not accept a substitute for our famous REED AND RATTAN FURNITURE, but write to our nearest store, mention his name, and you will be informed how to obtain our furniture.

HEYWOOD BROTHERS AND WAKEFIELD COMPANY
New York, Boston, Buffalo, Philadelphia, Baltimore, Chicago, San Francisco, Los Angeles, Portland, Oregon
J. C. PLIMPTON & CO., Agents, London and Liverpool, England.

SEND POSTAL TO-DAY FOR OUR BEAUTIFUL CATALOGUE

Catalogue G

Shows illustrations with descriptions and prices of many of our exclusive and beautiful styles of R E E D AND RATTAN FURNITURE. We make everything for which there's a demand.

Style 6613

Catalogue 7

is devoted exclusively to our well-known lines Heywood-Wakefield BABY CARRIAGES AND GO-CARTS. We guarantee them to be the finest and largest assortment made.

This is a 1902 magazine advertisement for the Heywood-Wakefield Company. In addition to the products listed, the company manufactured an amazing range of products, including baskets for hot-air balloons and all manner of cane furniture. The company had offices in New York, Boston, Philadelphia, Chicago, Baltimore, San Francisco, Los Angeles, and Portland, Oregon.

Some of the managers at the Heywood-Wakefield Company are, from left to right, Nicola M. Guillow (head designer), George Linnell (clerk at the rattan works), M. Lehman, and Henry T. Leavis (foreman of the rattan works). This photograph was taken in the 1890s by Horace Dalrymple and printed by Ernest Payro.

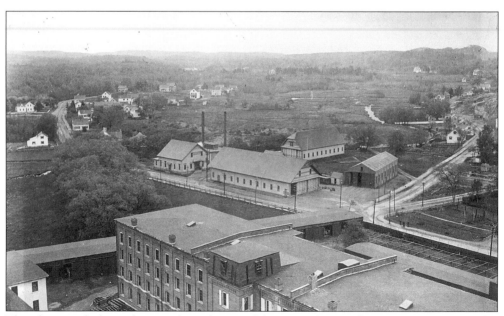

This photograph shows the view from the top of the rattan factory chimney in 1899. From this vantage point, looking to the southeast, Water Street winds out of sight.

A 20th-century advertising postcard of the Heywood-Wakefield Company earnestly requests that the reader inspect their goods, claiming that "three generations of Babies have ridden in Heywood-Wakefield carriages. Let your Baby have the same advantage." The Heywood-Wakefield Company remained in Wakefield until 1930.

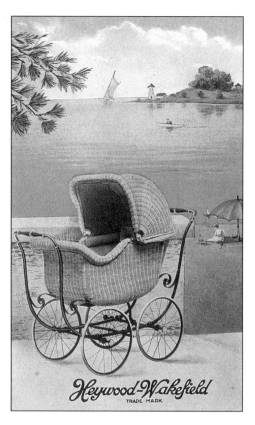

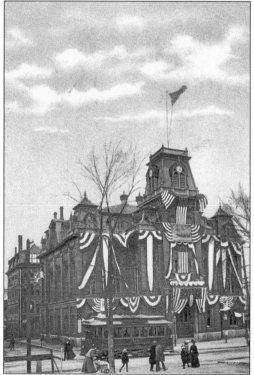

This early-20th-century postcard shows the Town Hall dressed up for an important occasion. The building served the town until a fire in the 1950s caused $95,000 damage. The building was torn down in 1958, and town government was relocated to the Lafayette Building—at a cost exceeding $95,000.

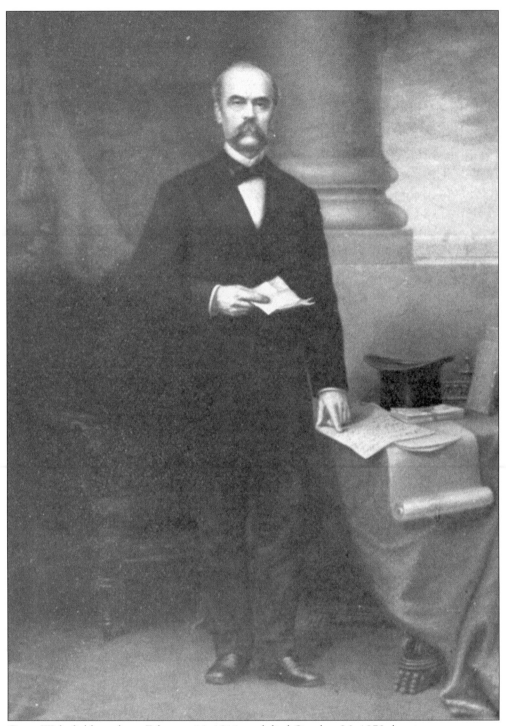

Cyrus Wakefield was born February 14, 1811, and died October 26, 1873, leaving an enormous legacy. This is a photograph of a larger-than-life-sized Thomas Badger portrait that flanked the stage in the Town Hall auditorium. (George Washington's portrait was on the other side of the stage.) The painting has been missing since the fire in the Atwell School in 1971.

Three

AN ENTERPRISING
COMMUNITY

This view of South Reading, Massachusetts, was taken from Hart's Hill in 1866. Note the young ladies at right enjoying the view.

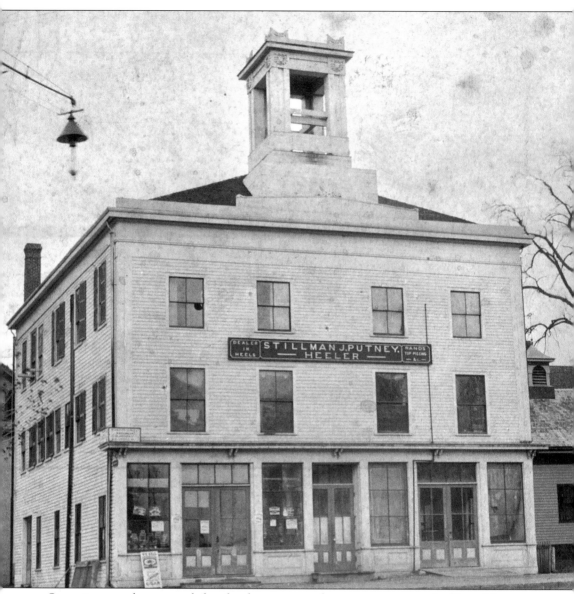

Since it was no longer needed as for the purposes of town government, the Town House was sold and moved to the southeast corner of Main and Salem Streets in 1873. As shown, it housed the establishment of heeler Stillman J. Putney among other concerns. The Paul Revere Bell, long hung in the steeple of this building, was moved to the steeple of the Lafayette Building in 1888.

Dr. Solon O. Richardson was one of the town's most successful 19th-century businessmen. His Richardson's Sherry Wine Bitters ("Its good effects are immediate") were purchased nationwide. Dr. Richardson was also renowned for funding the 1851 founding of the town's militia company, later called the Richardson Light Guard. He died in 1873 while making a social call at the home of his friend Cyrus Wakefield.

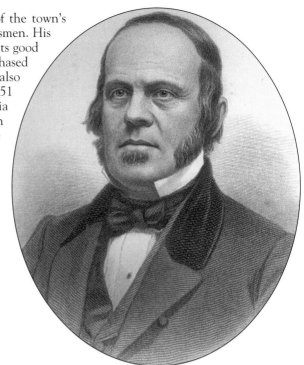

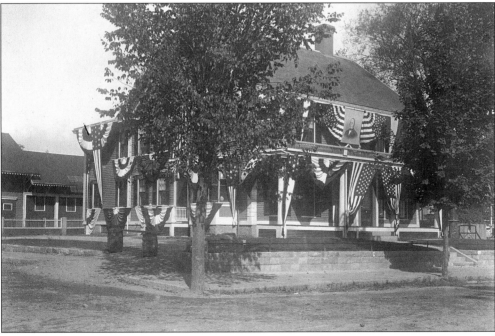

The home of Solon O. Richardson at its original site at the corner of Main Street and Richardson Avenue is shown decorated to celebrate the town's 250th anniversary in 1894. Moved to Richardson Avenue and Foster Street to make way for the construction of the Richardson Building, it was used for a time as a rooming house called the Colonial Inn. It burned while being torn down in 1971.

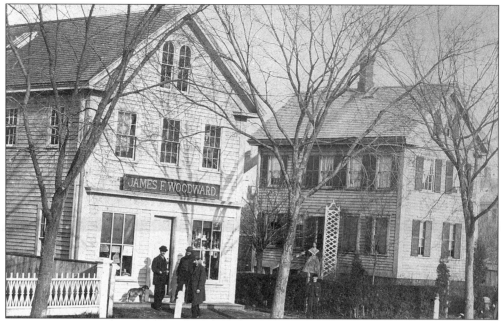

The Woodward Awl Factory is shown, c. 1865–1875. Here, at 111 Albion Street (on the north side of the street near North Avenue), the business established by Thomas Woodward in manufacturing tools for the shoe industry was continued and expanded by his son, James. The company was reputedly the first firm specializing in the manufacture of shoemakers' tools in the United States.

James Woodward's son, Charles Woodward, continued in the family business. He also remodeled his father's c. 1850 house into this structure, shown c. 1882–1883 with three generations of Woodwards. Note the streetlight in the foreground. The Citizens Gas Light Company of Reading, South Reading, and Stoneham had organized in October of 1859.

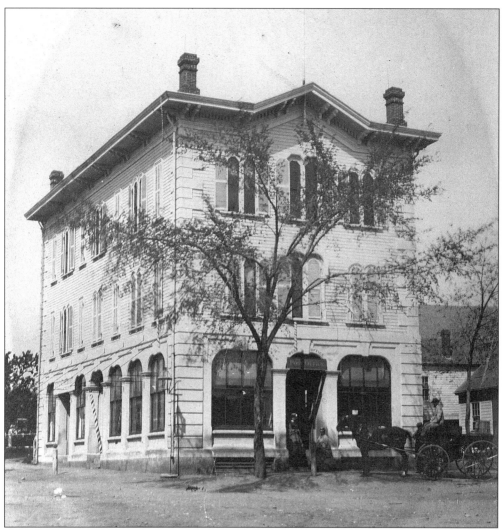

The post office leased space in the first floor of the 1852 Kingman Block on the corner of Main and Albion Streets. Note the barber pole on the left. On the right was a blacksmith shop, and the stable of Joshua Eams was in the rear. Note the elm tree in the front of the building.

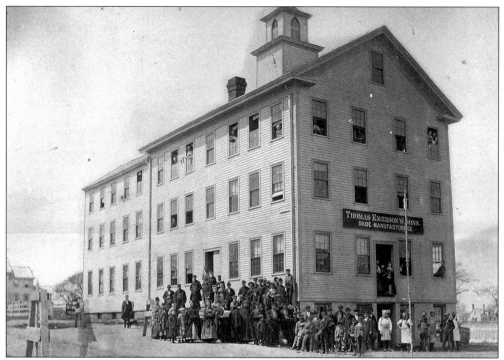

The Emerson Shoe Factory is shown in 1880. Thomas Emerson's Sons was the largest manufacturer of boots and shoes in Wakefield in the 1880s. The building, located on the corner of Main Street and Yale Avenue, had been Burrage Yale's Tin Shop and was remodeled and enlarged as the shoe factory. It was later demolished to make room for the YMCA building.

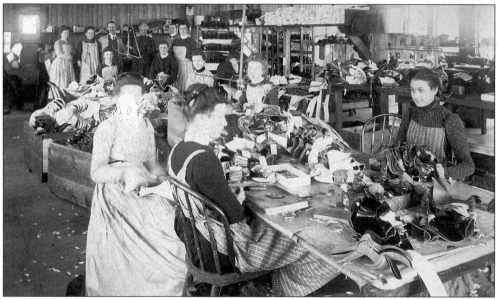

Wakefield shoe shop workers stop for a photograph, c. 1900. Women were involved in the manufacture of shoes in this town since the early 19th century. In 1835, a young woman named Eliza Wilder submitted a bill in the amount of $6.24 for binding shoes at 6¢ per pair. In the settlement, she was charged $1 for a pair for herself.

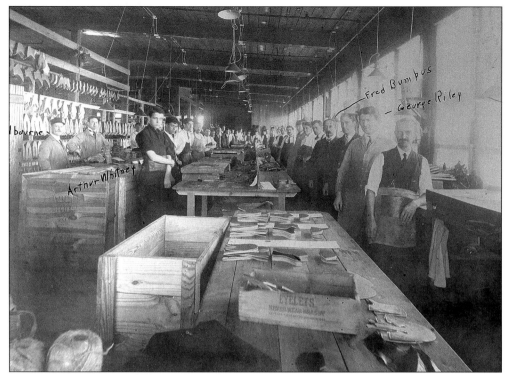

These gentlemen are workers in the cutting room of the L.B. Evans Shoe Factory, *c.* 1920. The company remained a substantial employer in Wakefield until 1987.

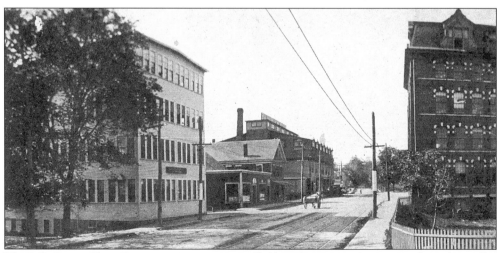

The L.B. Evans Shoe Factory on Water Street (left) is shown standing across from the Miller Piano Factory. Beyond the L.B. Evans building is Ira Atkinson's small grocery store and the Cutler Brothers huge wooden building. The large three-story L.B. Evans Shoe Factory was built in 1894. Substantially remodeled, it still stands at 27 Water Street.

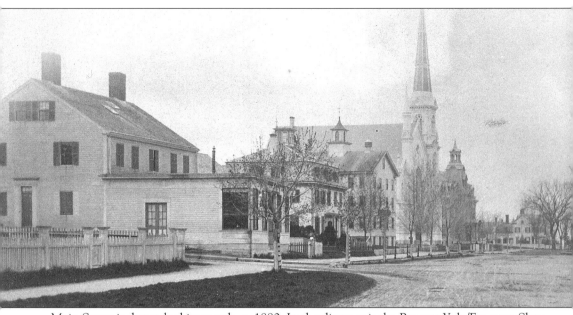

Main Street is shown looking north, *c.* 1880. In the distance is the Burrage Yale/Emerson Shoe

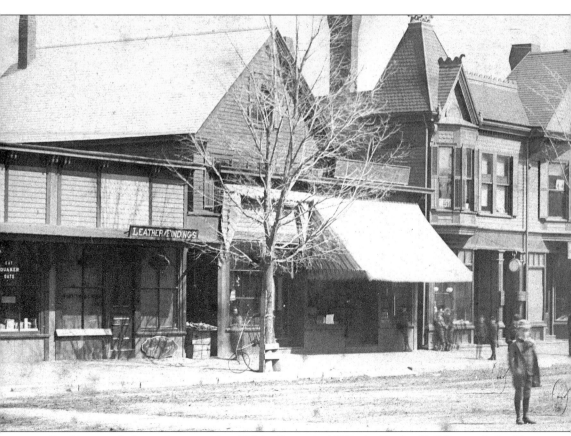

Looking south down the east side of Main Street in 1887, the Taylor Building and the Town

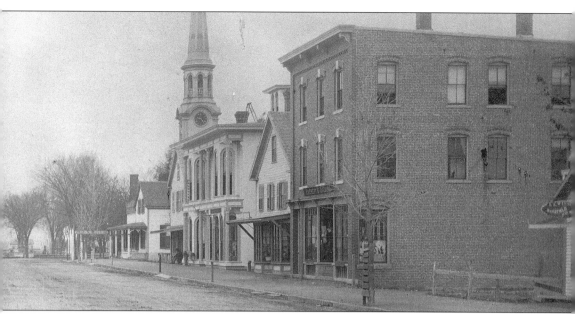

Factory, the Baptist church, the Lafayette Building, and the old Congregational church.

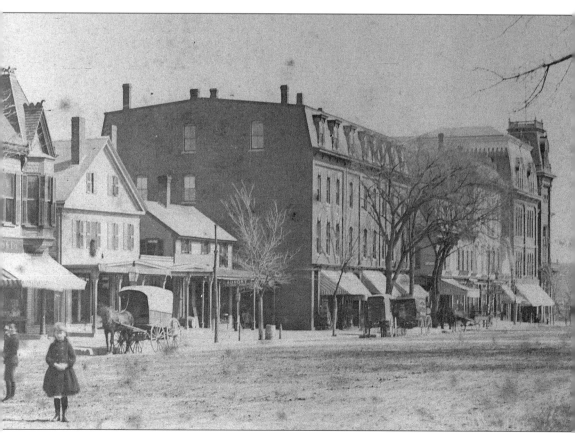

Hall are visible at the far right.

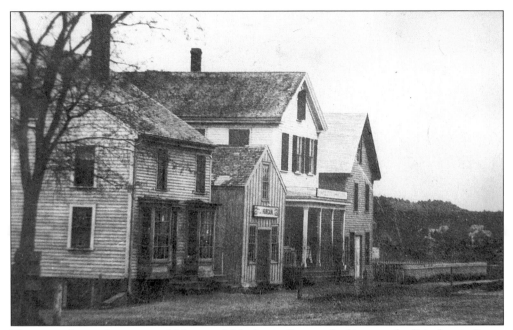

This view shows the corner of Main and Mechanic Streets, looking south. (Mechanic Street later became Princess Street.) The second building housed the T.J. Horgan Harness Shop. The Cooperative Store is the third building.

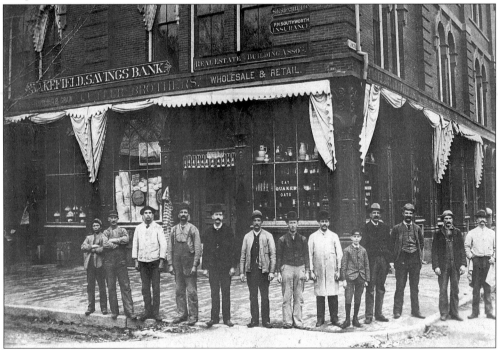

These gentlemen stand on the corner of Main and Lincoln Streets, approximately where the vacant lot appears at right on the photograph at the top of the page. The Taylor Building, constructed by Cyrus Wakefield, stands behind them. At that time, the building housed the Cutler Brothers dry goods store. The sign in the window advises, "Eat Quaker Oats."

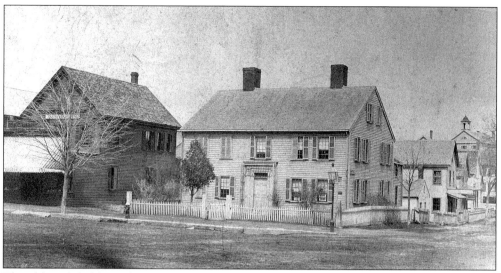

The old Archibald Smith House, built in 1807, stood on the north corner of Main and Centre Streets. This view is from 1886.

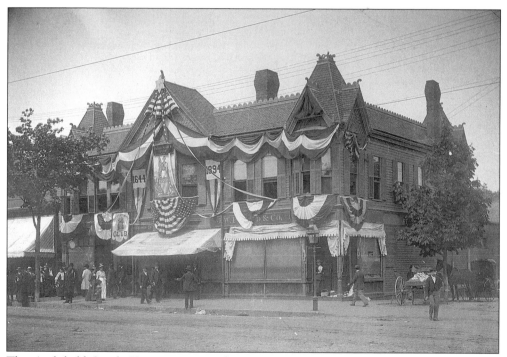

The Archibald Smith House was moved to Centre Street in order to make room for this structure. In 1894, the J.W. Poland dry goods store was located in the corner, and the Quannapowitt Club had quarters on the second floor. This building was in turn razed to be replaced by Parke-Snow's department store, which was replaced by Kline's, and then by Alano. The Archibald Smith House was demolished in 1942.

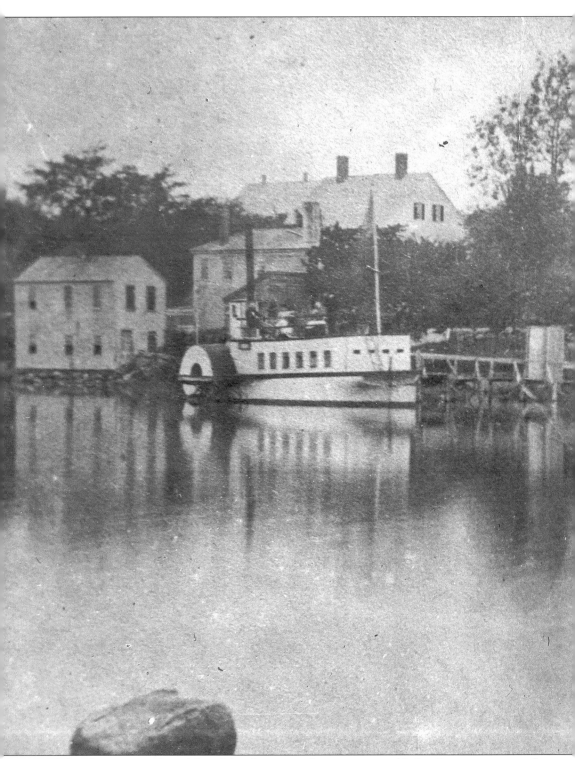

The pleasure steamboat *Minni Mariah* enjoys a leisure circuit of Lake Quannapowitt in this 1871 view. The large homes in the background belonged to the Emerson family of the Emerson

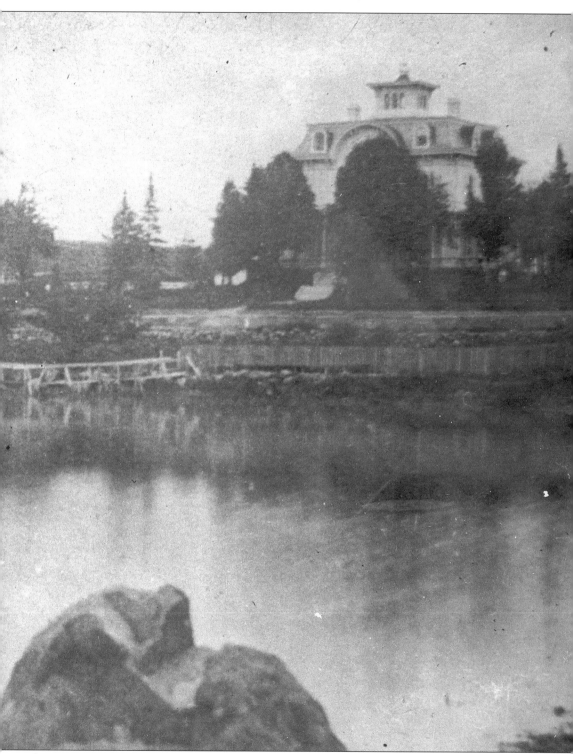

Shoe Factory. Note the building to the left, which is immediately upon the lakeside.

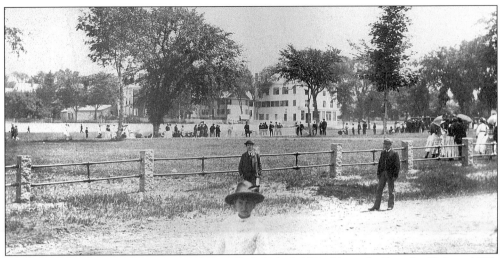

This view shows the Lower Common (also called Wakefield Park) on the Fourth of July in 1885. Park lands between Church Street and the lake were purchased at a cost of $19,600 in 1871; the lands were to be "an extension of the Common." Note that the park was fenced, an innovation. The girls at the right have brought along their parasols to protect them from the sun.

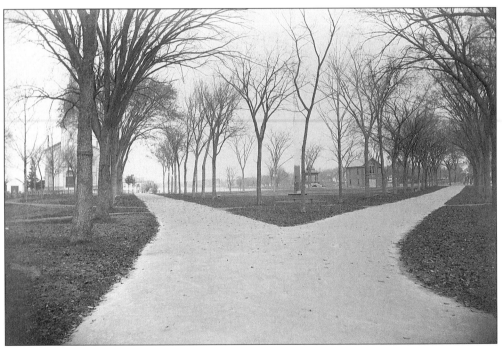

This view shows Wakefield Upper Common in the 1880s. In 1883, a South Reading native named Cornelius Sweetser left the town a $10,000 bequest for the beautification of a public park if the town would raise a similar sum for the same purpose. After some consideration, the town accepted the bequest. The old Common was drained, graded, and graveled; concrete walks were laid out. Note the Congregational church on the left (rear), the Bandstand, and the Yale Engine House at right.

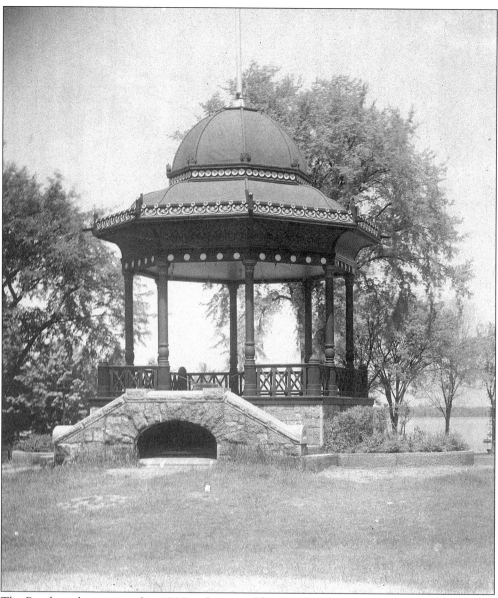

The Bandstand was erected in 1885 at the cost of $2,500. Bandstands were very popular in that era and were built as a combination of urban sculptures and common assembly places. At a time of increasing industrialization, the erection of bandstands allowed cities and towns to impose some beauty upon their increasingly disorderly growth.

Superior Court.

EX

Emily B. Lovejoy.

STENOGRAPHER.

The harvesting and sale of ice, begun in Wakefield *c.* 1849, became a very important industry in Wakefield. This 1913 photograph shows one of the large icehouses, owned by the Morrill-Atwood Company, on the site of Veteran's Field. The Hartshorne House can be seen in the center of the photograph.

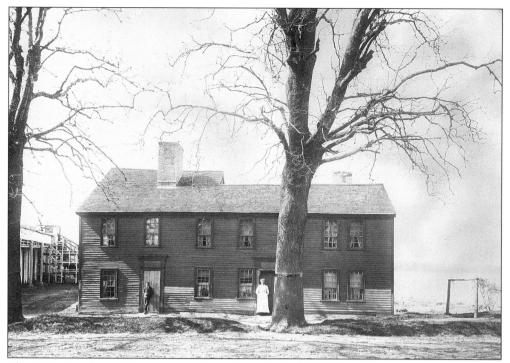

The 1681 Hartshorne House was used as a tenement for icehouse workers from 1890 until 1929. Note the icehouse at left.

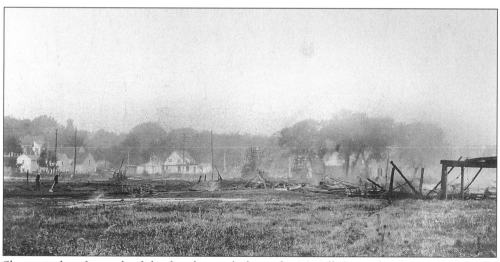

Shown is the aftermath of the fire that took down the Morrill-Atwood icehouses. Taken the day after the conflagration, this photograph depicts the complete devastation of the area. The Hartshorne House, the only building left standing, was subsequently purchased by the Town of Wakefield and restored as a historic site.

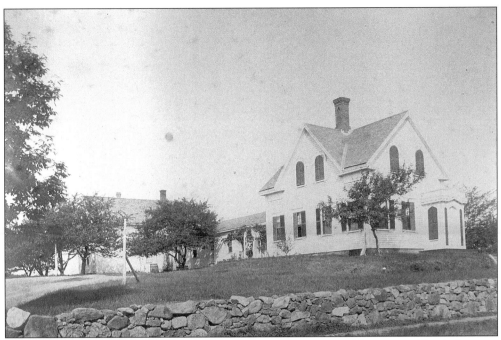

This is a view of the Boston Ice Company's house on the corner of the present North Avenue, c. 1876. The Boston Ice Company had a very large presence in Wakefield, with 29 icehouses on Lake Quannapowitt alone.

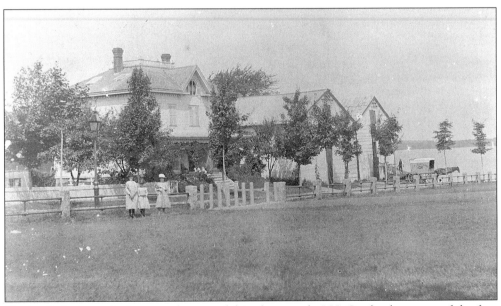

Cartland's Icehouse is shown at the rear of this photograph. J.H. Cartland was one of the four smaller ice dealers in town whose carts made regular circuits of the town selling ice.

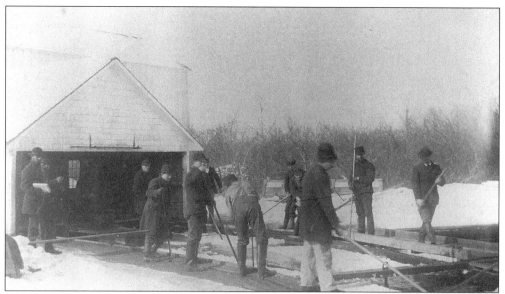

Cutting ice on Lake Quannapowitt was a sideline for many local men, who picked up extra work during the icehouses' busy seasons. Ice was cut on Lake Quannapowitt until 1947.

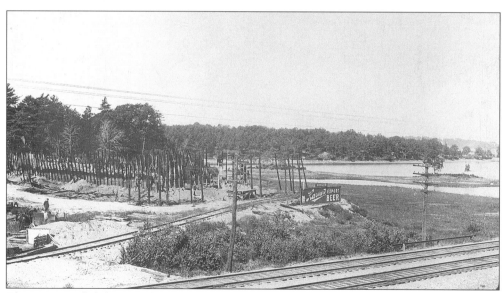

The remains of Philpot's Icehouse on Crystal Lake are shown in this view. The icehouse burned on July 3, 1911. Icehouses, whose walls were insulated with cork, were very flammable. Notice the siding or spur track in this photograph. Ice could be packed into railroad ice cars for shipment to Boston and beyond. The advertising sign says, "Demand Harvard Export Beer."

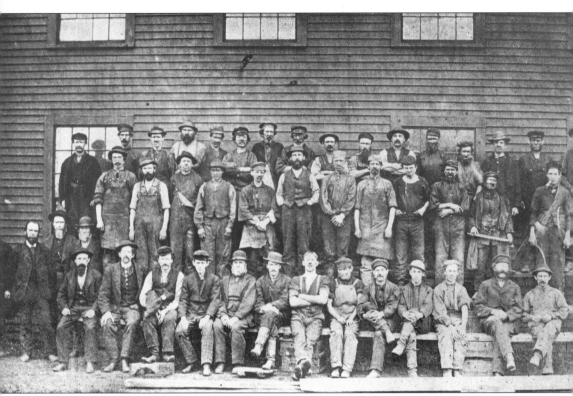

Workers at the Boston and Maine Foundry pose for a photograph in this early view. The foundry, located on Foundry Street, manufactured stoves and other cast-iron products. It was reputedly the first business in the United States to manufacture enameled bathtubs.

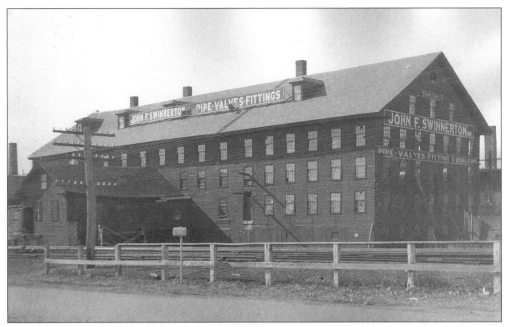

The Smith and Anthony Company's Hub Stove Foundry succeeded the Boston and Maine. In its heyday, the Smith and Anthony foundry was the second largest establishment in Wakefield. The company manufactured iron and brass stoves, ranges and heaters, and was the exclusive manufacturer of "Sanitas" plumbing appliances (water closets). Swinnerton's factory, shown here, succeeded the Smith and Anthony Company in this location.

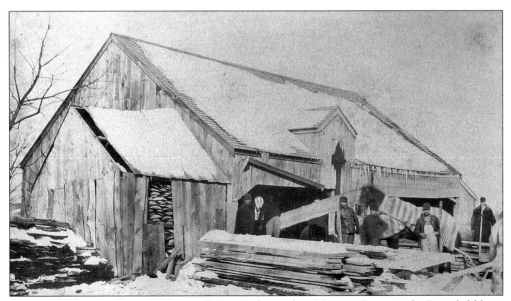

The Bickford Sawmill on the Saugus River was located on Vernon Street at the Lynnfield line. This view was taken on February 22, 1890.

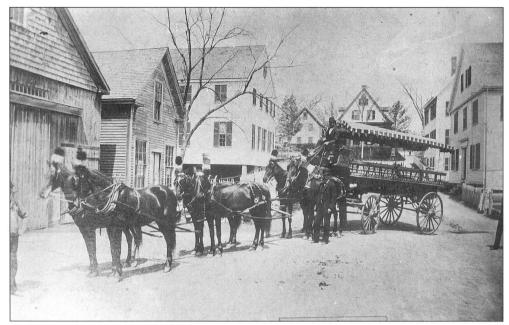

Hathaway's Six Horse Barge, also known as "the Queen of the Turf," was stabled on Princess Street in 1885. The barges were rented from a livery stable and used as a charter bus would be used today.

Albion Street was predominately residential in the late 19th century. This photograph shows the street in 1887.

The Greenwood Station is shown in this *c.* 1910 view. When the railroad came to Greenwood in 1844, the area was transformed almost overnight into a suburb of Boston. In addition, Greenwood proliferated with groves (precursors to public parks), which were private woods available for picnics and woodland rambles. The Greenwood Station building was eventually sold to the Pleasure Island amusement park. It burned to the ground on April 1, 1971.

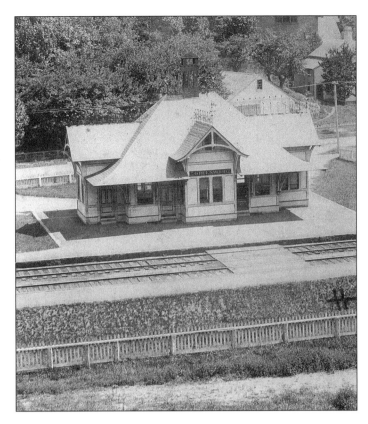

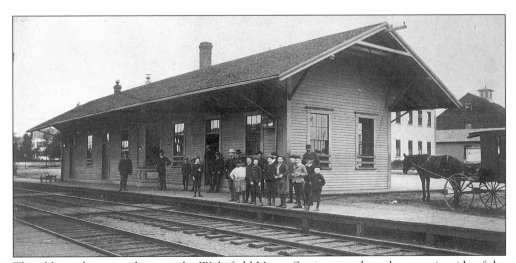

The old wooden train depot at the Wakefield Upper Station stood on the opposite side of the tracks than the present station. The new brick station was built in 1890.

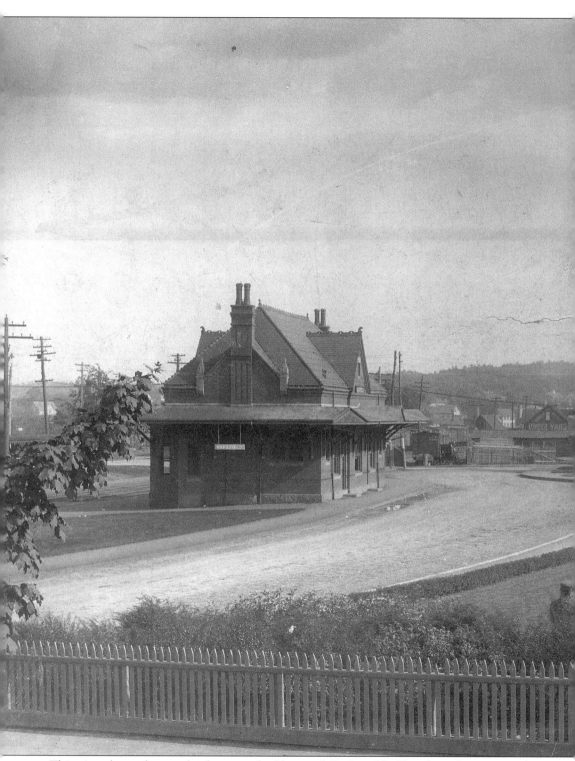

This view shows the new brick station building and St. Joseph's Church as they appeared in
1910. The cornerstone of this church building, a remodeled and enlarged version of the original

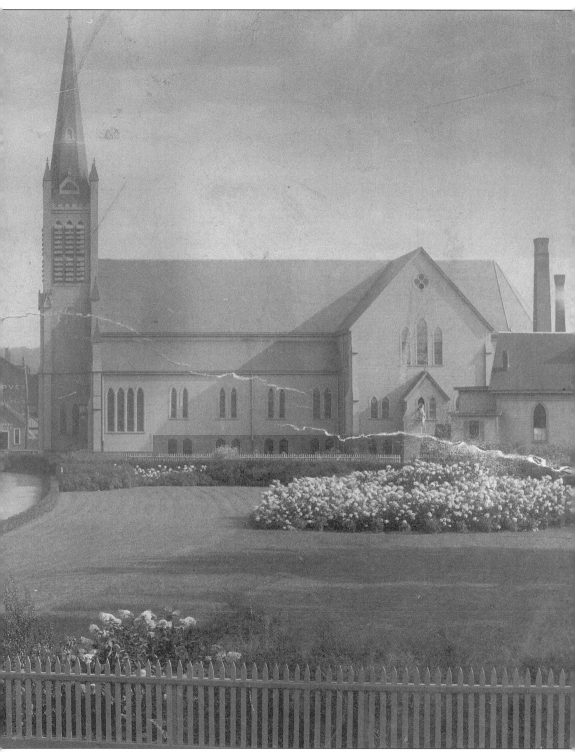

1871 church, was laid on September 8, 1889. Note the Hub Stoves building in the background.

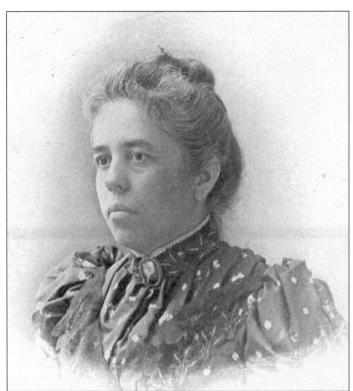

Elizabeth Eaton Boit and Charles Winship pooled their resources of $2,500 and their knowledge of the mill industry to form the Harvard Knitting Mills (later Winship Boit and Company) in 1888. In 1889, the company moved to Wakefield, employing the entire third floor of the Taylor Building at Main and Lincoln Streets. In 1895, there were 160 employees, mostly young ladies. Elizabeth Eaton Boit, shown here, was born in 1848.

The Harvard Knitting Mills grew so rapidly that the company began construction on a new building at Albion Street and North Avenue in 1897. By 1921, they employed 850 workers or 5 percent of the knit workers in New England. They produced 4.5 million pounds of yarn a year and more than 21,000 garments daily.

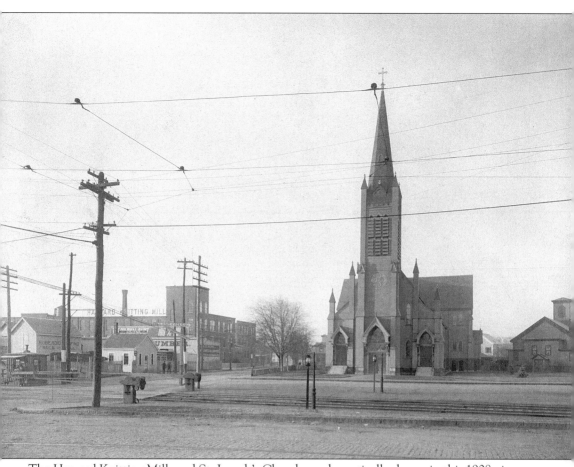

The Harvard Knitting Mills and St. Joseph's Church are dramatically shown in this 1908 view.

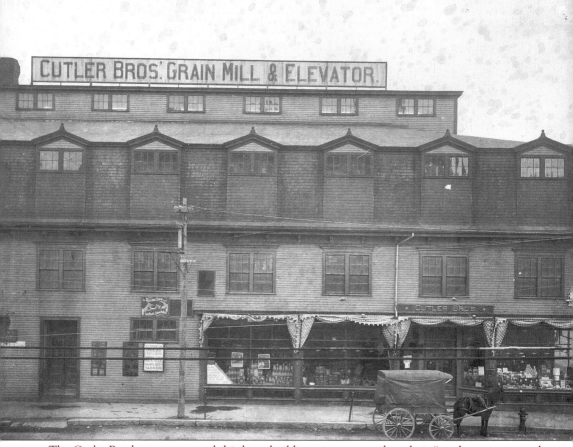

The Cutler Brothers constructed this large building to accommodate their "modern grocery and grain business." The business was first established on the first floor of the Wakefield Block (Main and Lincoln Streets). The company moved to this new building on the southeast corner of Main and Water Streets in 1891. The building was lighted by an independent electric light plant and contained grain elevators with storage capacity of 50,000 bushels.

This view shows the wooden Massachusetts State Armory Building, built in 1894 as the home of the Richardson Light Guard. The building stood across the street from the present Americal Civic Center, and was immediately adjacent to the Cutler Building.

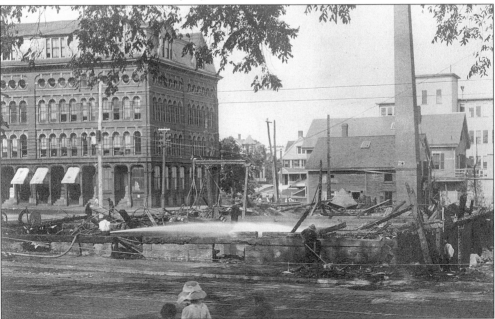

On July 6, 1911, a lightning storm ignited the Cutler Brothers building in a spectacular fire that threatened the Town Hall across the street and caused serious structural damage to the wooden armory building beside it. The aftermath of the fire is shown here.

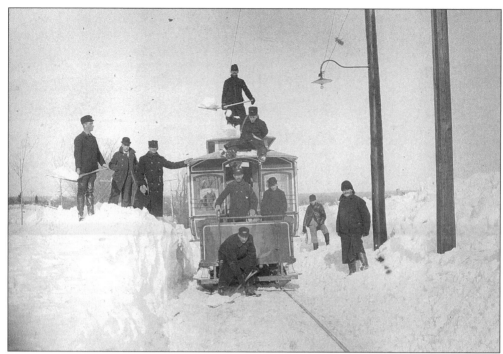

A Wakefield and Stoneham Street Railway car is shown here after a snowstorm in 1893. The company obtained a charter in 1892, using tracks laid from the post office in Wakefield to the junction of Main and Elm Streets in Stoneham, and tracks over Main and Albion Streets in Wakefield and Elm and Main Streets in Stoneham.

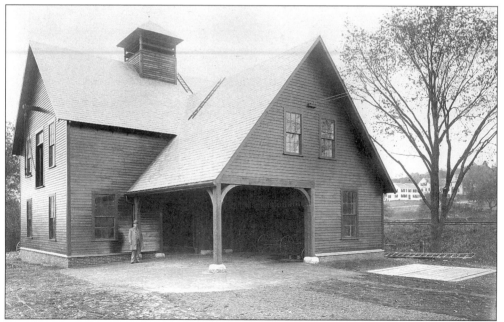

This photograph shows the barn at the Municipal Light Company plant on North Avenue in 1893. Standing outside is Superintendent Wallace. The Town of Wakefield purchased the plant, land, and manufacturing equipment of the old Citizens' Gas and Light Company in 1893.

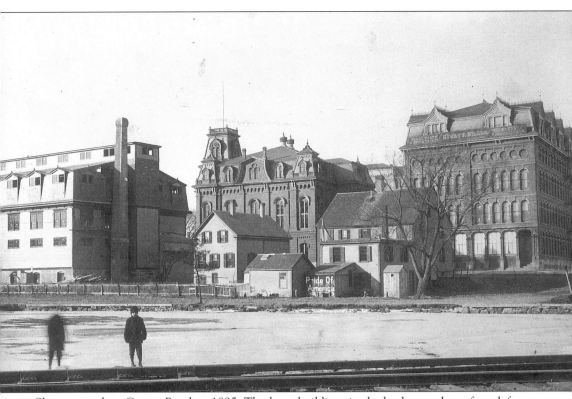

Skaters stand on Center Pond, *c.* 1895. The large buildings in the background are, from left to right, the Cutler Building, the Town Hall, and the Miller Piano Factory. The L.B. Evans Shoe Factory, built in 1894, was to the right of the buildings in the foreground. The Episcopal church, built in 1881, was east of the factory. In 1900, the church was moved to the corner of Main and Bryant Streets, and the L.B. Evans building was extended easterly onto the former church site.

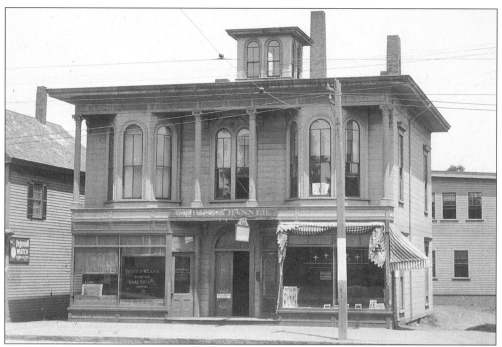

The office of the Wakefield Citizen and Banner is shown on Main Street, *c.* 1890. The *Wakefield Citizen and Banner* was a weekly newspaper first printed in 1874 by William H. Twombly of Camden, Maine. He sold the newspaper to Chester W. Eaton in 1880. Note that Chester W. Eaton's real estate business is also advertised on the building's windows.

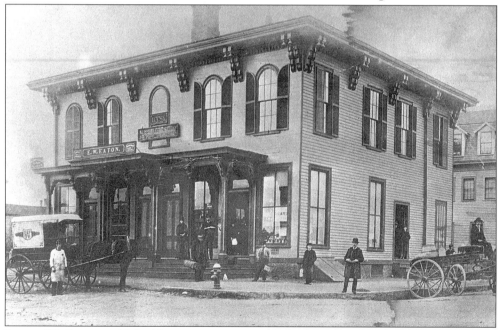

Everett W. Eaton established his grocery store in this bank building on the corner of Railroad (North Avenue) and Albion Streets in 1863. In both the buildings on this page, one can note the Italianate style of architecture, which was immensely popular in Wakefield in the 19th century.

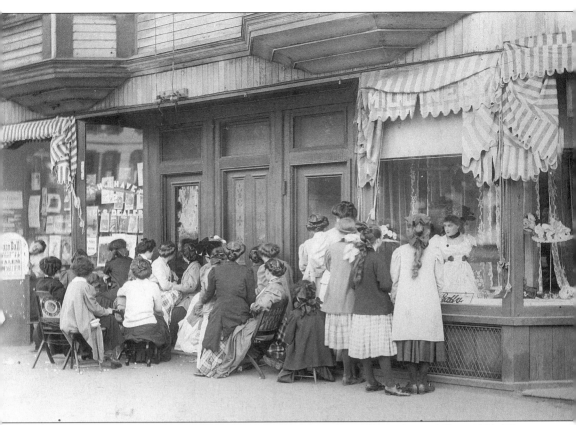

Women wait for tickets to the annual May Festival, a town tradition from 1860 to 1931. The festival was a fundraising activity for the Universalist Church; children of all denominations took part in a dance program. The location of the shops in this photograph is the approximate site of the present CVS.

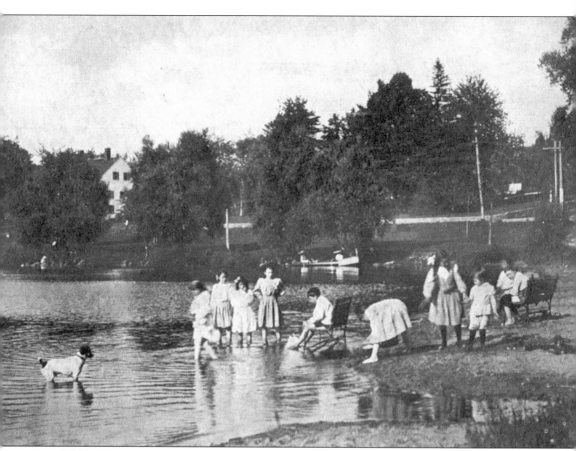

Children enjoy the beach at Lake Quannapowitt in this early postcard.

The Rockery, shown here *c.* 1907, was erected in 1884 at the instigation of the one of the park commissioners, "Honest Jim" Carter. Originally known as the Sylvan Grotto, it was meant to be the "oasis of Main Street."

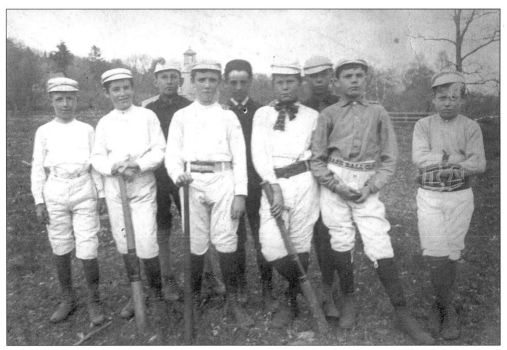

The members of the Mayflower baseball team pose in July 1888. The cupola of their school building rises in the distance behind them. The team included Walter E. Curry, Ernest F. Curry, George Magill, Arthur Burke, Robert Gibson, George Munn, Orington Hopkins, Frank Cheever, and Willie McLean.

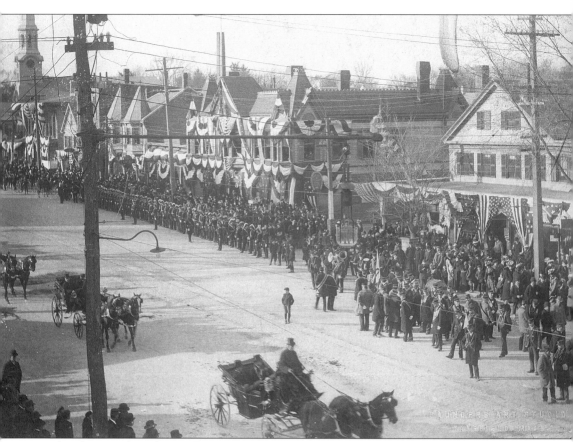

This photograph of the Knights Templar parade in 1893 shows the east side of Main Street. The Universalist church is in the top left corner. Note the electric light in the foreground.

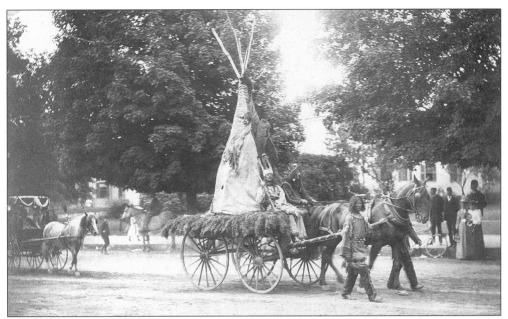

The town's commemoration of its 250th anniversary in 1894 was a gala celebration. Shown here is a Native American float; the sponsor is unknown. Wakefield's well-known Wahpatuck Tribe No. 54 of the Improved Order of Red Men was not organized until 1909.

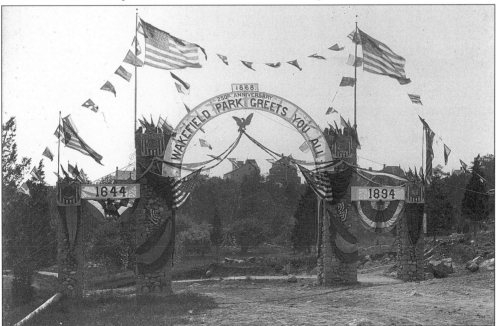

The entrance of the new suburb of Wakefield Park was festooned with bunting during the town's anniversary celebration in 1894. Wakefield Park was developed as a planned community when J.S. Merrill and Charles Hanks put together more than 100 acres in Wakefield and Stoneham with lot size restrictions that would keep the development priced for the upper middle class. The park was promoted for its healthy atmosphere, beauty, and other rural qualities being sought by city dwellers for whom the garden suburb was the ideal.

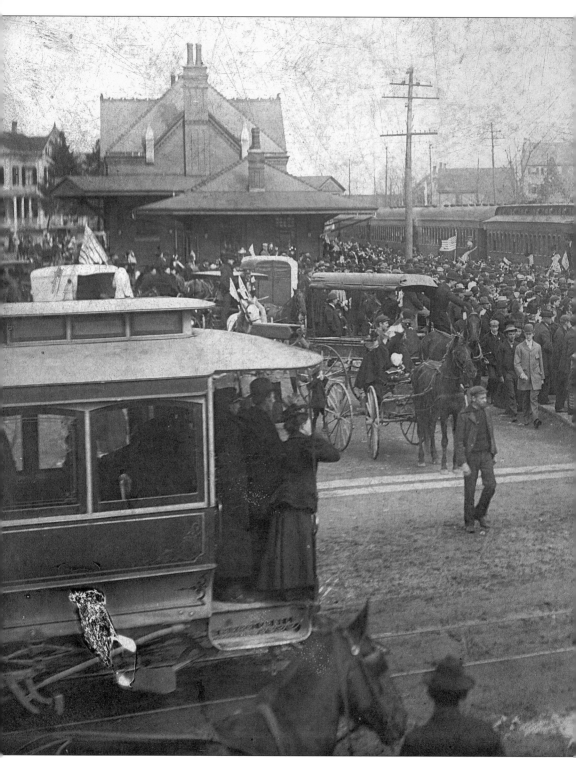

The town turned out at the Upper Station in a heartfelt send-off of the Richardson Light Guard, Company A, 6th Regiment MVM for camp in South Framingham on May 6, 1898,

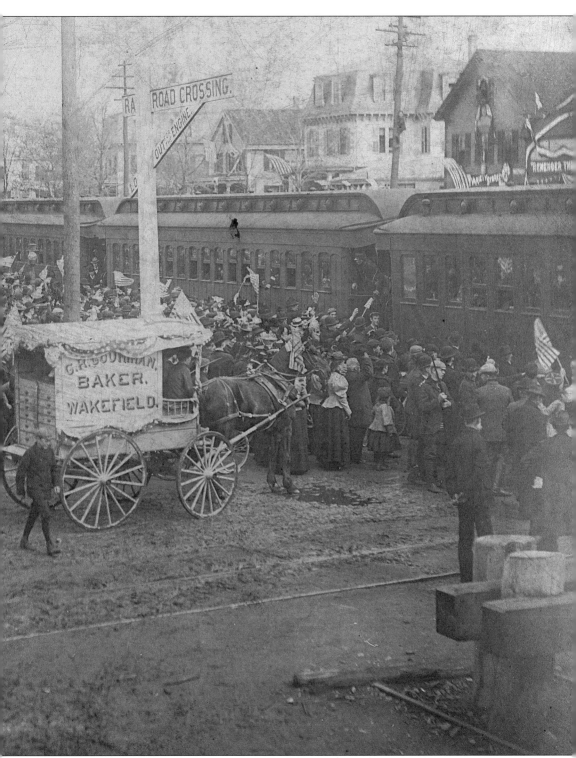

during the Spanish-American War.

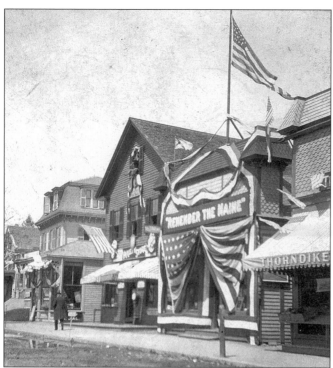

This shop on North Avenue is decorated in 1898 to bid farewell to the Richardson Light Guard as it left for the Spanish-American War.

The Rifle Team, Company A, 6th Regiment of the Richardson Light Guard, of Wakefield was much renowned for its marksmanship in the 1890s.

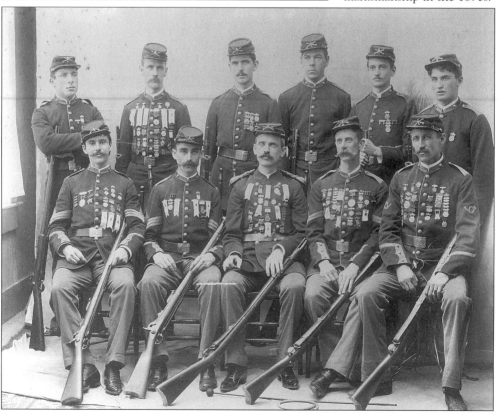

Four

A NEW CENTURY

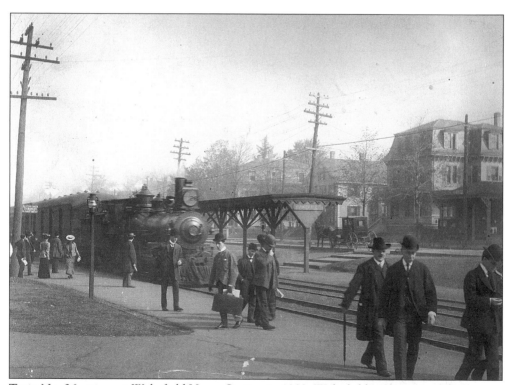

Train No. 26 arrives at Wakefield Upper Station in 1903. Wakefield at the turn of the century had a well-developed industrial character, but had also become a streetcar suburb, with commuters traveling back and forth to Boston from homes in the healthful suburbs.

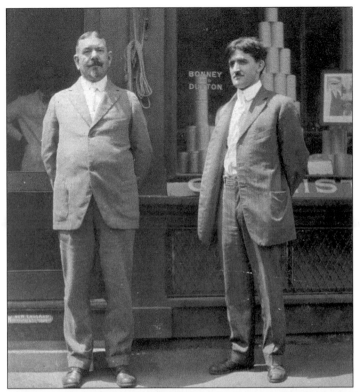

Josiah S. Bonney and Riberot Dutton were proprietors of the Bonney and Dutton Drug Store on the corner of Main and Albion Streets. Riberot Dutton's photograph collection has become an invaluable resource for the Wakefield Historical Society.

The interior of the Bonney and Dutton Drug Store is shown here *c*. 1907–1908. Pictured are Robert Dutton, Nat Eaton, Ernest Daland, and Josiah Bonney.

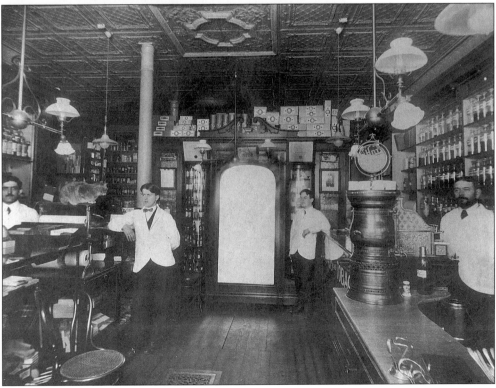

Tom Webb, who was employed as a driver for Tom Dwyer, is shown outside the Bonney and Dutton Drug Store. Across the street are Boothby's clothing store, a luncheonette and soda shop, and Smith's Drug Store.

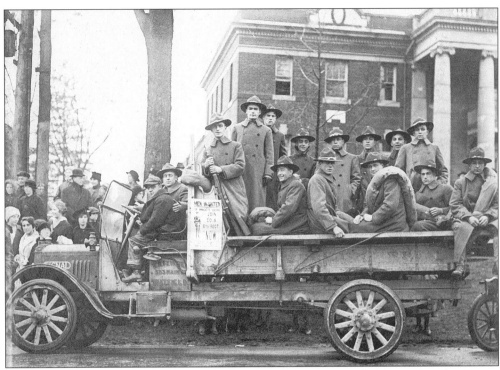

Company A is preparing to depart for World War I in this 1917 photograph. The armory building (now the Americal Civic Center) can be seen in the background.

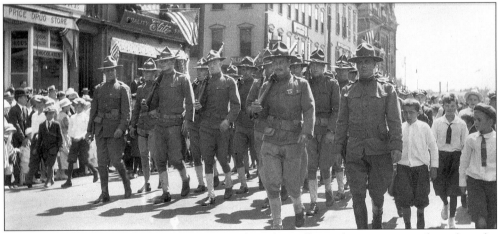

Company A marches down Main Street in their farewell parade, moving northward to the Common. The company members shown are, from left to right, Lt. Fred Rogers, bugler Daniel Galvin, Frank W. Gammons (slightly behind Galvin), an unidentified man, Sgt. George W. Stone, and Capt. (later Col.) Edward Connelly. Colonel Connelly later became the first commander of the Corporal Nelson Post of the American Legion. The beach at the head of the lake was named after him.

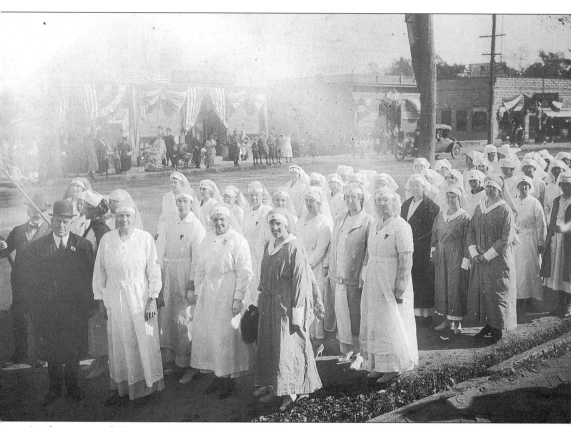

At the return of Company A, the town turned out to welcome them back. Shown is the Red Cross section of Welcome Home Day on October 13, 1919.

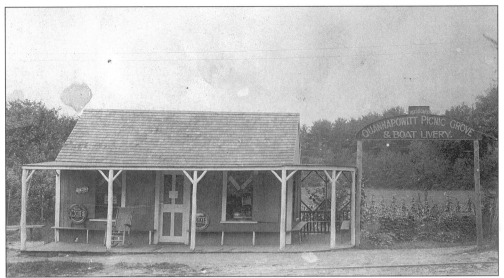

Rosson's Quannapowitt Picnic Grove was located at the northern end of the lake. Note the advertisements for Moxie.

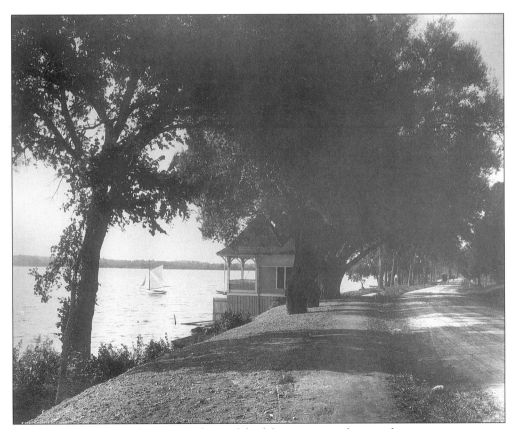

Wright's Boathouse on the eastern shore of the lake was privately owned.

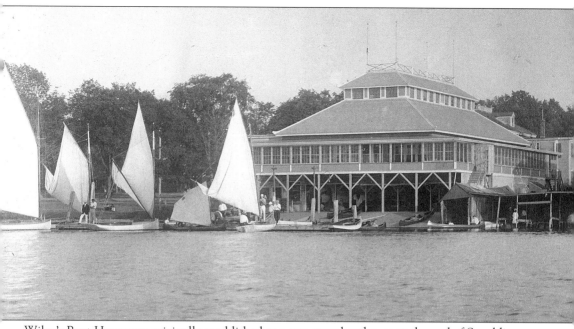

Wiley's Boat House was originally established as a one-story boathouse at the end of Spaulding Street in 1872. In 1887, Albert S. Wiley erected a new one-story building at the end of Lake Street. The structure received a second story that housed a dance hall and soda fountain in 1912. The boathouse was sold to the Hill family in 1923 and did a thriving business for many years. The property was sold to the town in 1963 and was subsequently demolished.

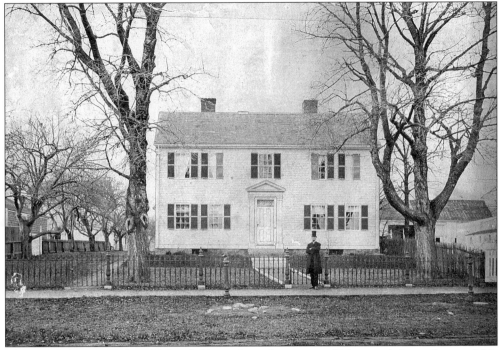

The stately home of Edward Mansfield stood on the corner of Main and Avon Streets. This view is from *c.* 1860.

The same area appears in this view from 1930. The Beebe Memorial Library, designed by the architectural firm of Cram and Ferguson, was dedicated on April 15, 1923. Junius Beebe, the son of Lucius Beebe, made the town a gift of $60,000 to help pay for the building. The town had named the public library the Beebe Town Library of Wakefield after Lucius Beebe's donation of $500 for books in 1868.

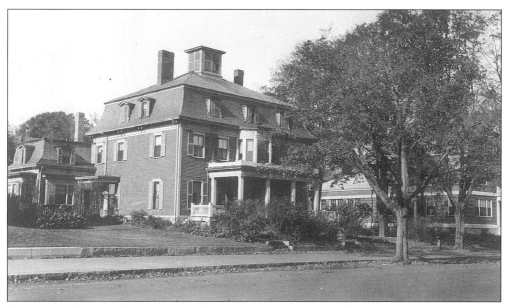

The home of Mr. and Mrs. John W. White stood on the corner of Main and Yale Avenue. The building sported the mansard roof and cupola so popular in the 19th century.

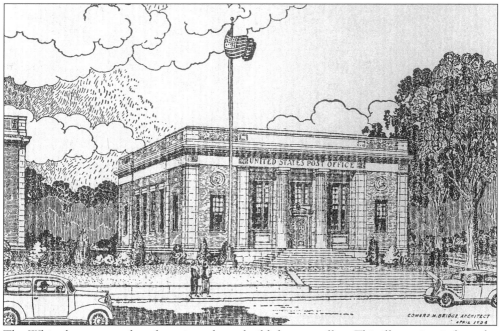

The White home was taken down in order to build the post office. This illustration is from the cover of the dedication booklet, January 27, 1937. The building had been designed by local architect Edward Bridge.

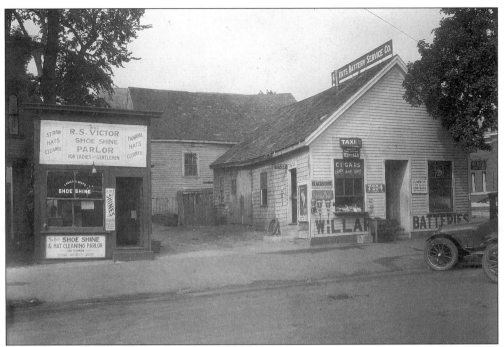

The R.S. Victor Shoe Shine Parlor and the Roberts Battery Service Company stood approximately on the corner of Main and Chestnut Streets.

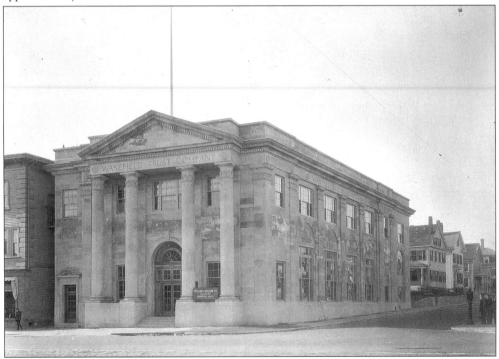

The structures shown at the top of the page were razed for the construction of the Wakefield Trust Company in 1924. In the rear is the Bessey home (built *c.* 1830–1840), which would be purchased by the bank in 1963 in order to provide a parking lot for its clientele.

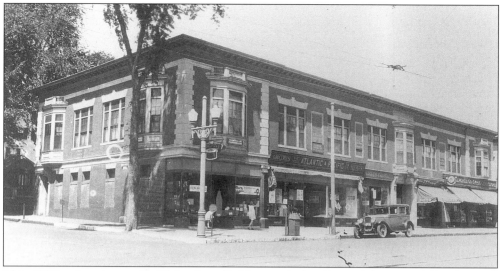

This 1930s view shows the Richardson Building and the Great Atlantic and Pacific Food Company. Farther down the block is J.J. Newberry's. The Richardson Building had been built on the site of his family's home by Solon O. Richardson. He subsequently laid out Richardson Avenue.

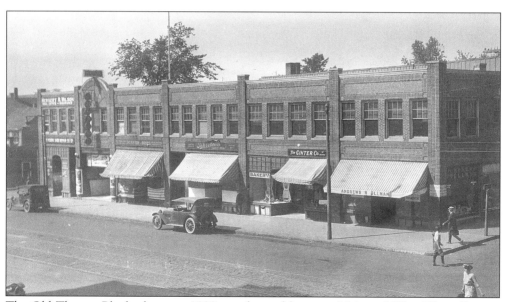

The Old Theater Block, shown c. 1930, was located between Main and West Water Streets. The block burned in 1971.

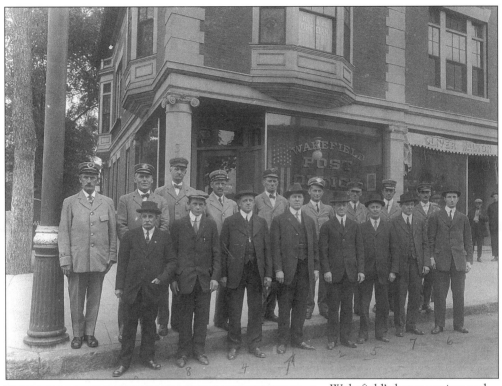

Wakefield's letter carriers and clerks are shown in this 1915 view outside the post office on the corner of Richardson Avenue and Main Street. Adjoining businesses included the shop of Oliver Walton and the home of "the Best Ice Cream Soda in Town" for only 5¢.

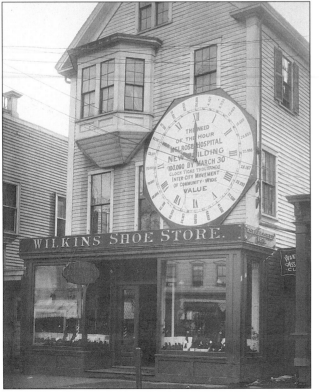

The Wilkins Shoe Store, located on the west side of Main Street just south of the old Bonney and Dutton Drug Store, sported a clock that advertised the need for funds for a new building for the Melrose Wakefield Hospital.

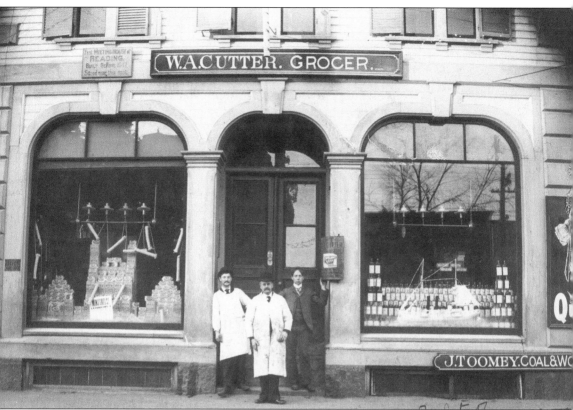

This 1905 photograph shows the W.A. Cutter grocery store, located in the Kingman Block on the corner of Main and Albion Streets. A sign for a minstrel show presented at the H.M. Warren Camp can be seen, along with advertisements for Sunlight Soap and Hires Root Beer on the storefront. A large sign advertising Quaker Oats is partially visible at right. The small sign immediately to the left of the shop sign says, "First Meetinghouse of Reading, built before 1642, stood near this spot."

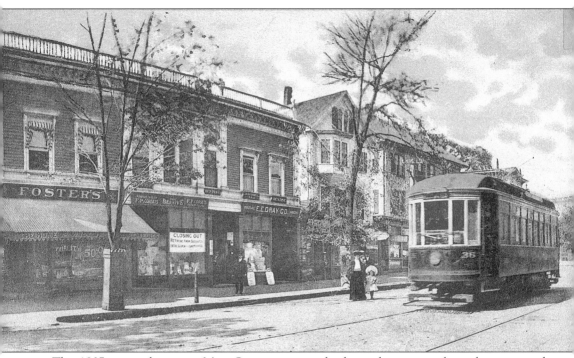

This 1907 postcard, viewing Main Street going north, shows the streetcar lines that increased the town's desirability as a suburb. On the west side of the street one found Foster's Store, the

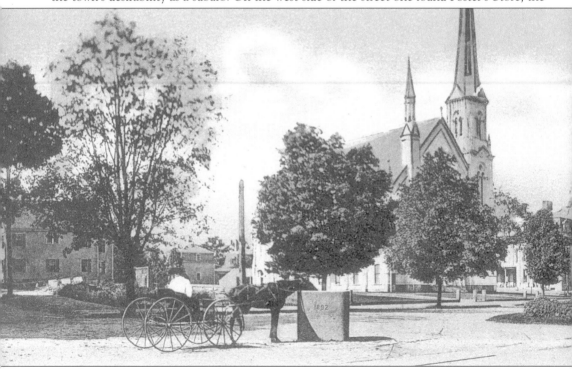

The Baptist church and the Rockery appears in this early-20th-century postcard of Wakefield. Note the watering trough, dated 1892, in the middle of the street. This postcard predates the

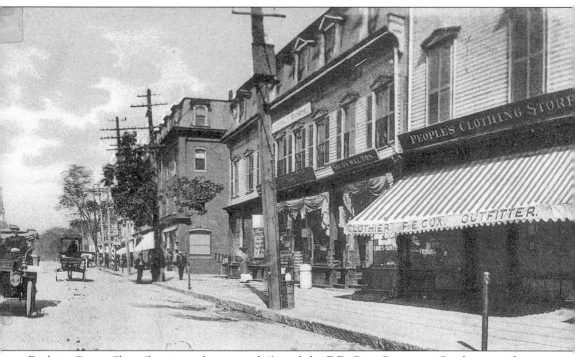

Beehive Corset Shop (having a close-out sale!), and the E.E. Gray Company. On the east side of the street stood the People's Clothing Store (R.E. Cox, outfitter).

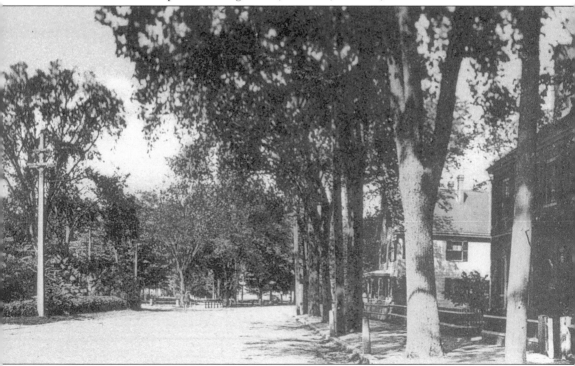

YMCA building and the post office.

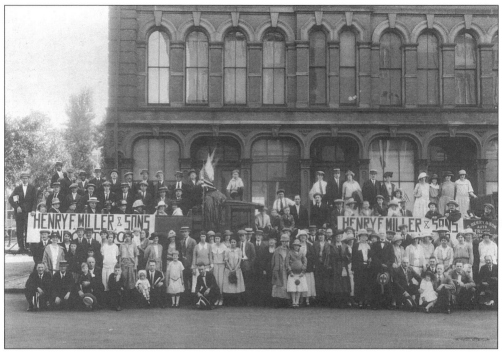

The employees of the Miller Piano Factory pose here with their families. The Miller Piano Company was originally established in Boston in 1863 by Henry F. Miller. Occupying a large brick building built by Cyrus Wakefield on Smith Street (the present site of Fleet Bank), the plant covered more than an acre of ground and was the company's home from 1884 to 1932. The factory building, constructed in 1872, was demolished to make way for the construction of the Surety and Trust Company building.

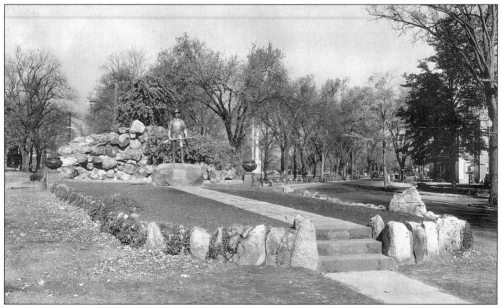

On October 12, 1926, the Hiker Memorial by Theodore Kitson was erected in honor of Wakefield citizens who took part in foreign action during the Spanish-American War.

Five

SCHOOL DAYS

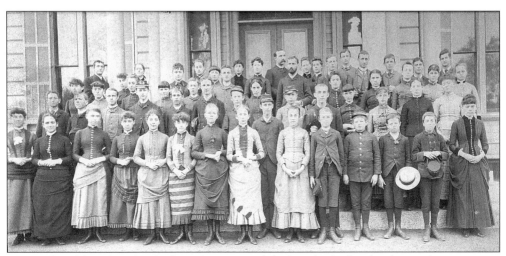

The Wakefield High School Class of 1888 stands before the high school on Lafayette Street. Teachers included Mr. Russell, Mr. Jackson, and Miss Butterfield.

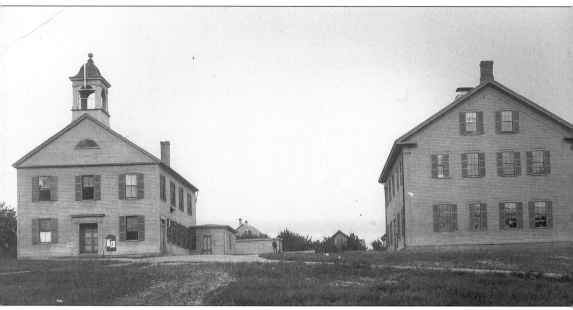

This view shows "Academy Hill" before the erection of the Lincoln School on the site. These buildings of the Baptist South Reading Academy, established in 1829, were purchased by the town. The structure on the left was used as the town's first high school from 1847 until 1870. It was later moved to 7 Foster Street and became the Grand Army of the Republic Hall. It is now privately owned. The building on the right was used as a grammar school. It was later moved to Crescent and Princess Streets and converted to the fire station. The station was destroyed in the fire that leveled the Hathaway Stable in 1899.

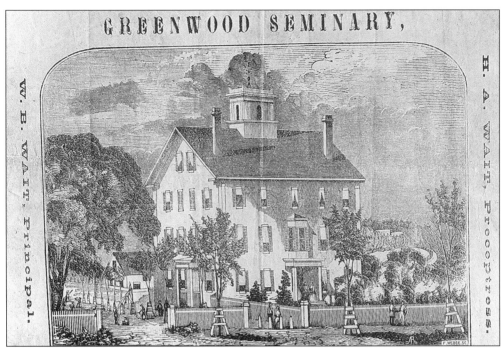

This illustration is from a handbill from the Greenwood Seminary, a privately owned institution that reached its heyday in 1853. Upon his retirement from the seminary, the proprietor, Reverend Waitt, returned to his previous occupation as a mechanic. After closing as a school, the building was used as a "home for inebriates that was very successful from 1872 [to] 1874." It later burned to the ground.

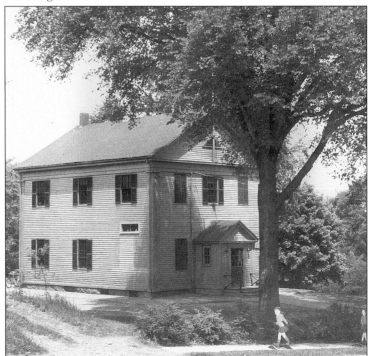

The West Ward School is pictured *c.* 1930. Constructed as one of four ward schools to serve the town of South Reading in 1847, the West Ward School is the only one of those schools still standing. The building was used as a day-to-day school until 1994. Today, it is being restored as a living history classroom.

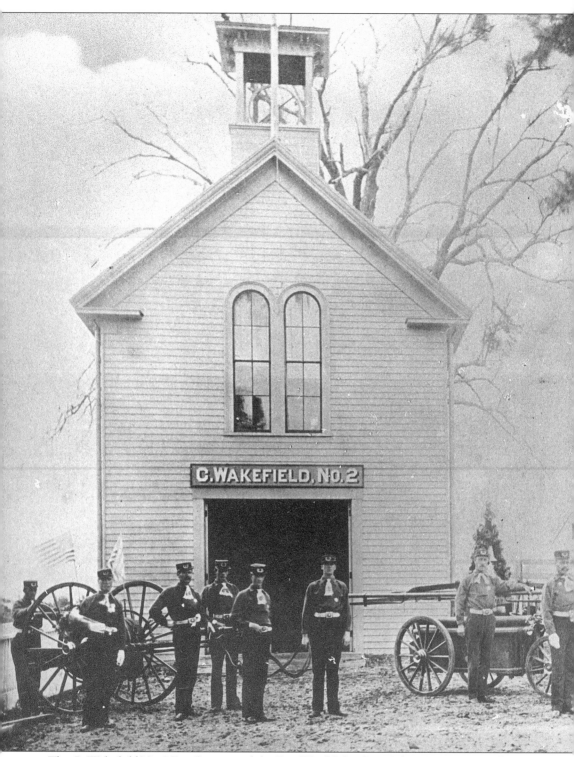

The C. Wakefield No. 2 Fire Station and the East Ward School, on Salem Street at Lowell Street, are shown in this 1885 image. The school building was closed at the construction of the Montrose

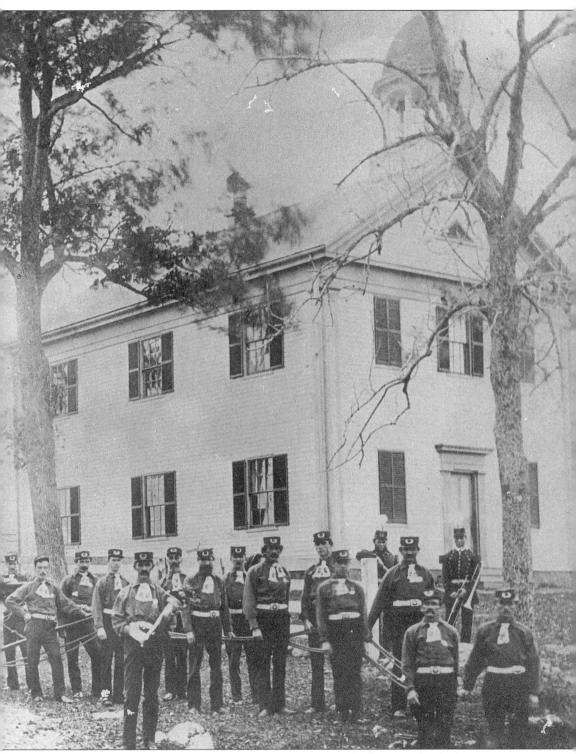

School in 1918. The engine house burned on May 4, 1899. In the foreground is the hose company with the 1850 hand tub built by Howard and Davis and the Hunneman two-wheel hose reel.

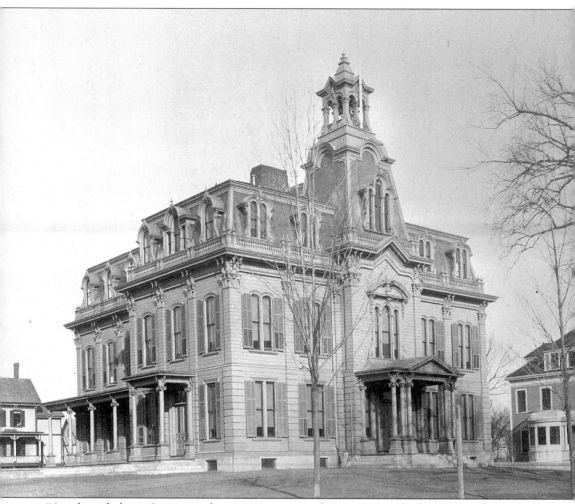

"Ample and elegant" was one description given to the town's new high school in 1871. The structure was used as a high school until 1923, when a new high school was built. Eighth-graders occupied this building (then called the Lafayette School) until 1936. The structure underwent a significant "improvement" in 1937 by the Works Projects Administration as a major relief project, which obliterated most of its architectural detail. The building became the Town Hall in 1958 and underwent a significant remodeling in 1999.

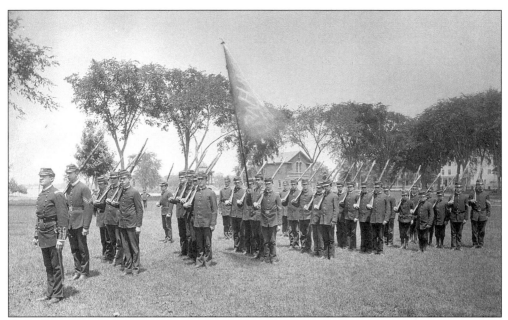

Wakefield High School cadets drill on Wakefield Upper Common before 1903. In the background are the Bandstand and the Yale Engine House on the present Lower Common. Just visible at the right is the old Town House, which originally stood just west of the Yale Engine House. The Yale Engine House was moved to Main Street in 1873 and was torn down in 1903.

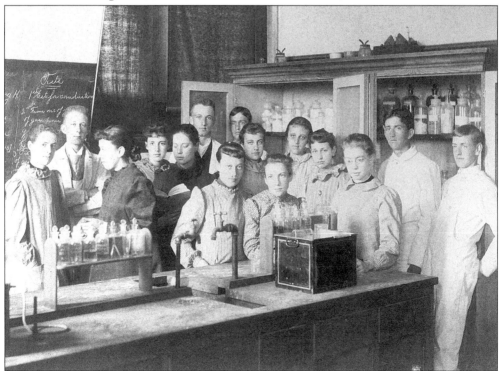

Wakefield High School students pose in the chemical laboratory on the third floor of the high school on Lafayette Street.

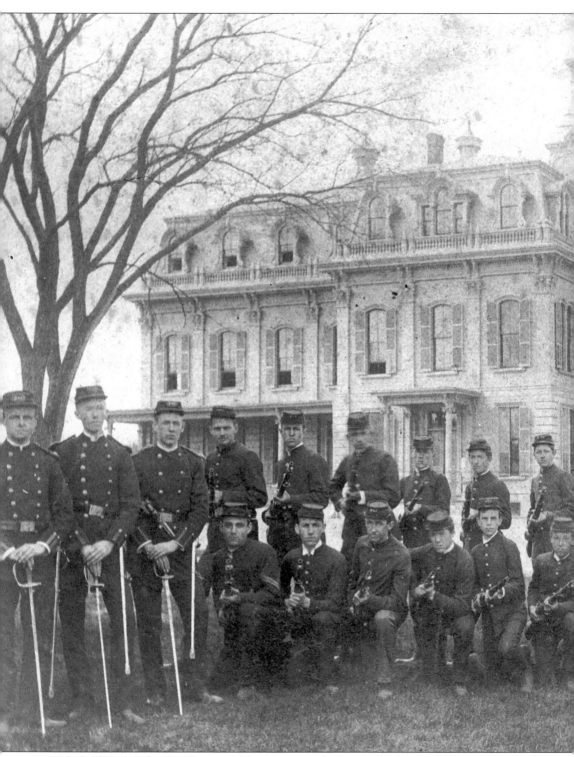

Wakefield High School cadets in 1888 strike a pose before the high school. In October 1885, the boys of the high school had formed a military company and entered the 2nd Massachusetts

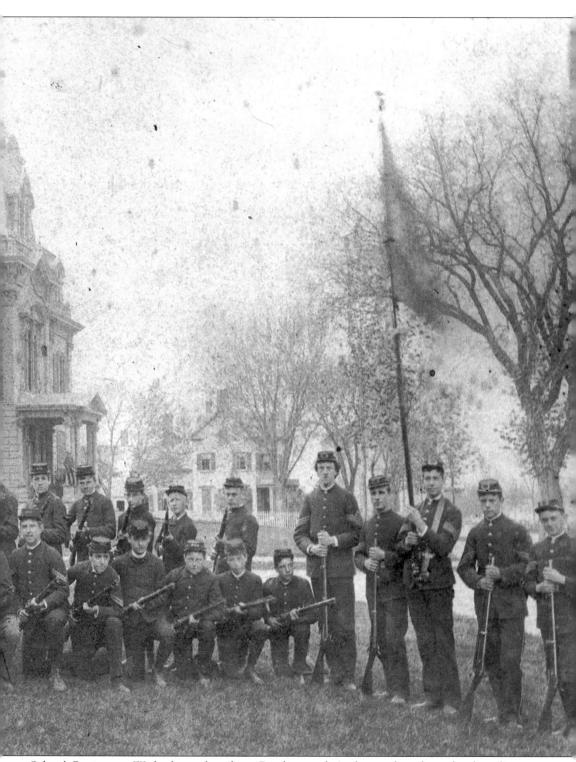

School Regiment. With the cadets from Reading and Andover, they formed a battalion. Military drill ceased in 1931 because of overcrowded conditions in the school.

The Lincoln School is shown *c.* 1910. The school was built in 1892 and was closed in 1981 as a result of budget cutbacks with the implementation of Proposition $2^1/2$. (Other schools that closed that year included the Warren, the Woodville, and the Yeuell. The Yeuell subsequently reopened.)

Early students of the Lincoln School pose on the school's steps.

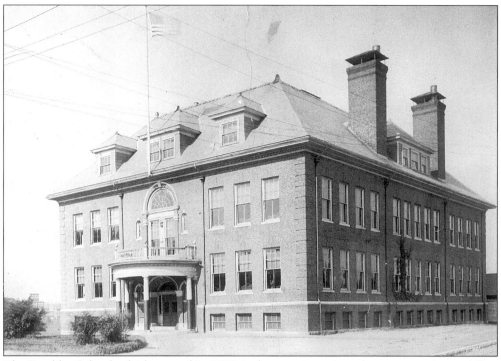

The Franklin School, which opened in 1902, is shown prior to its enlargement and remodeling in 1925.

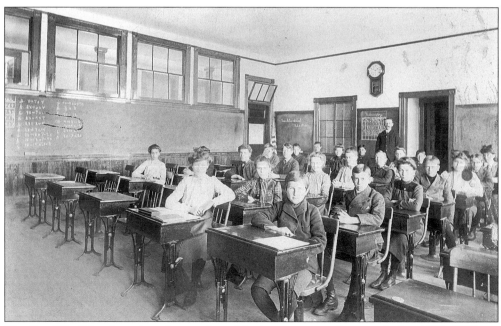

The Franklin School was brand new when this classroom was photographed *c.* 1902–1903.

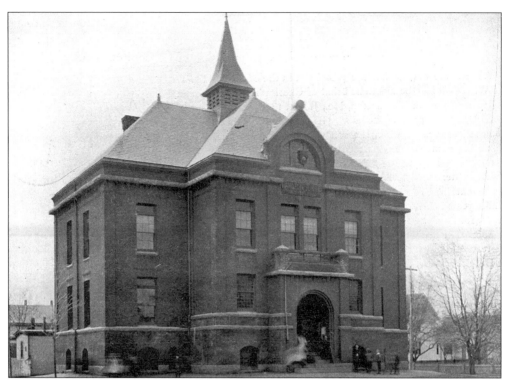

The Hamilton School, named for Samuel K. Hamilton, was built in 1888 and was located on the corner of Albion and Lake Streets. It was later torn down to provide a parking area for the employees of Transitron.

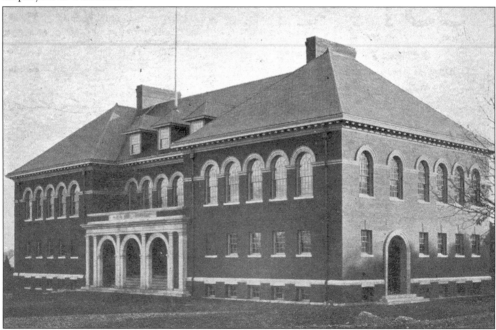

The Warren School, built in 1895, was named after Maj. H.M. Warren, who was killed during the Civil War. The school closed in 1981 and is now being remodeled for use as a senior center.

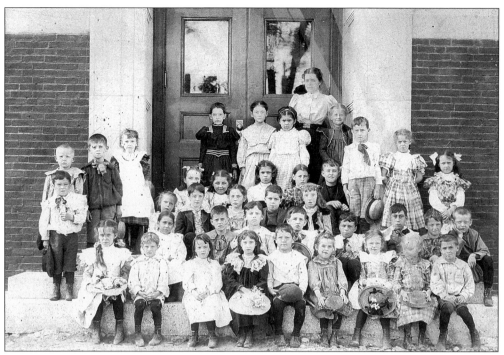

Second-grade students pose at the Hurd School during the school's first year in 1899.

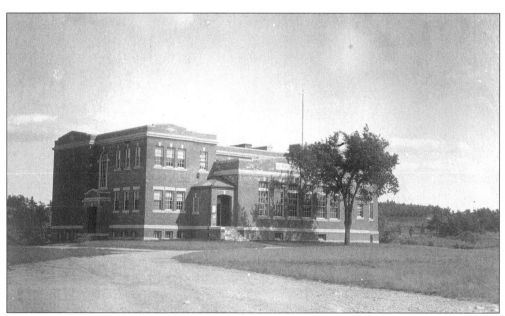

The Woodville School, built in 1920, replaced the old North Ward School that had stood in its location. This building will be replaced by a much larger Woodville School building.

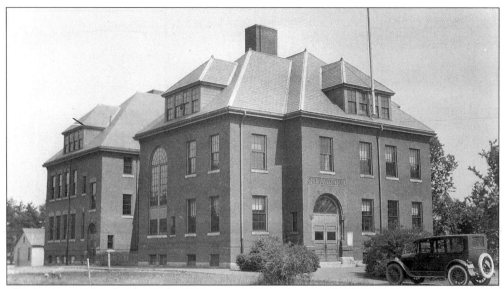

The Greenwood School was built in 1896. This photograph shows the school before its enlargement and remodeling in 1925.

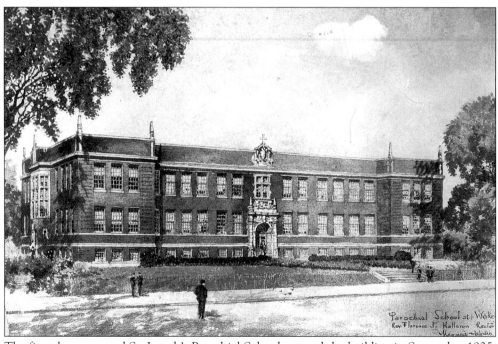

The first class to attend St. Joseph's Parochial School entered the building in September 1925.

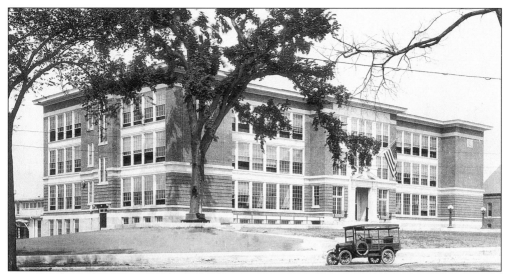

The new high school was erected on the site of Cyrus Wakefield's estate. The high school opened in 1923. An extension to the building was built in 1955, at which time the high school was moved into the extension. The original building was renamed the Willard J. Atwell Jr. High School and used for that purpose until the new junior high on Farm Street opened in 1960.

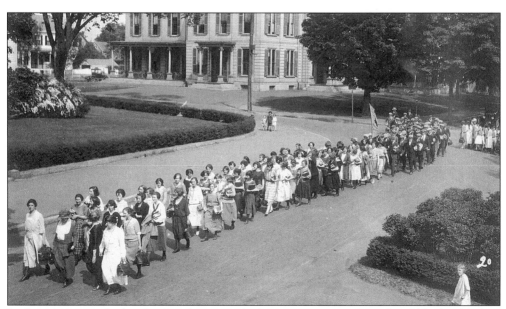

In this 1923 view, high school students parade down Main Street from the old high school on Lafayette Street to their new school at the present location of the Galvin Middle School.

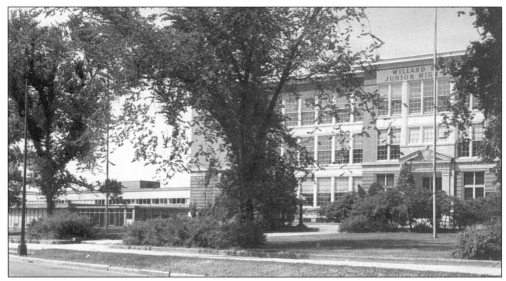

The Atwell Building, shown here in the late 1950s, burned in December 1971. Town meeting approved the conversion of the junior high into Wakefield High School in 1972 along with the construction of a sixth-grade facility at the Atwell site.

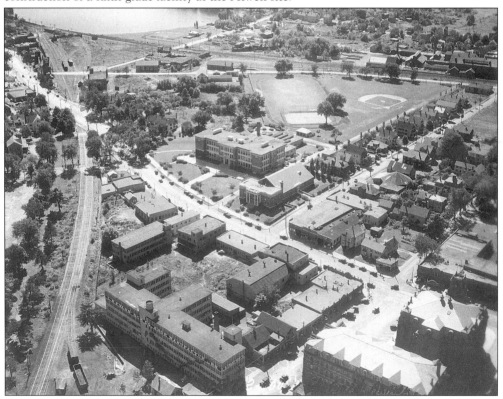

This aerial view of South Main Street shows the high school building and the adjoining Americal Civic Center (then the state armory) in the center. The L.B. Evans Shoe Factory is at the lower left, and the roof of the old Town Hall, with the Miller Piano Factory behind it, is at the lower right.

Six

FIRE!

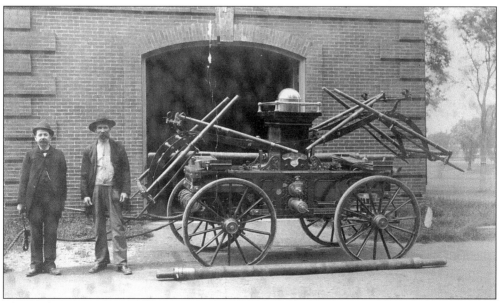

The William Jeffers hand tub, known as Yale No. 1, was placed in service in 1853. This *c.* 1871 photograph shows Owen Corcoran (left) and Steward David Graham.

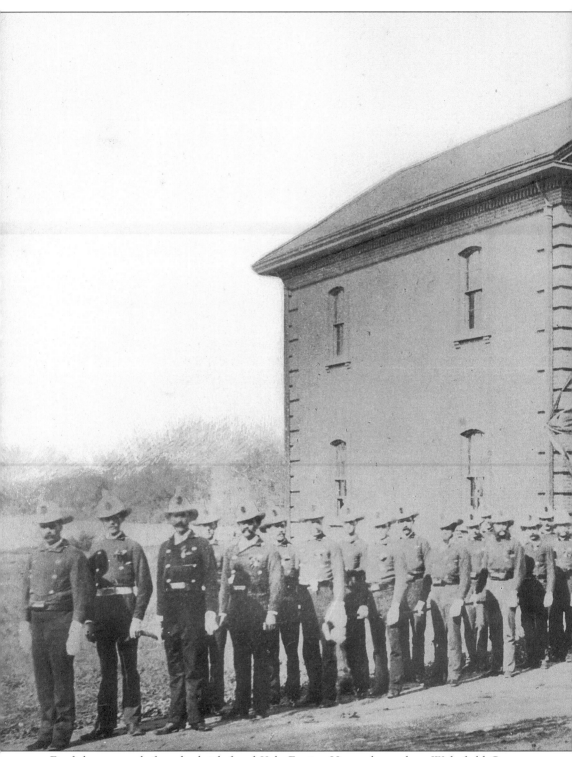

Firefighters pose before the brick-faced Yale Engine House, located on Wakefield Common. The shield placed on the engine house announces, "Fire Our Servant Not Our Master."

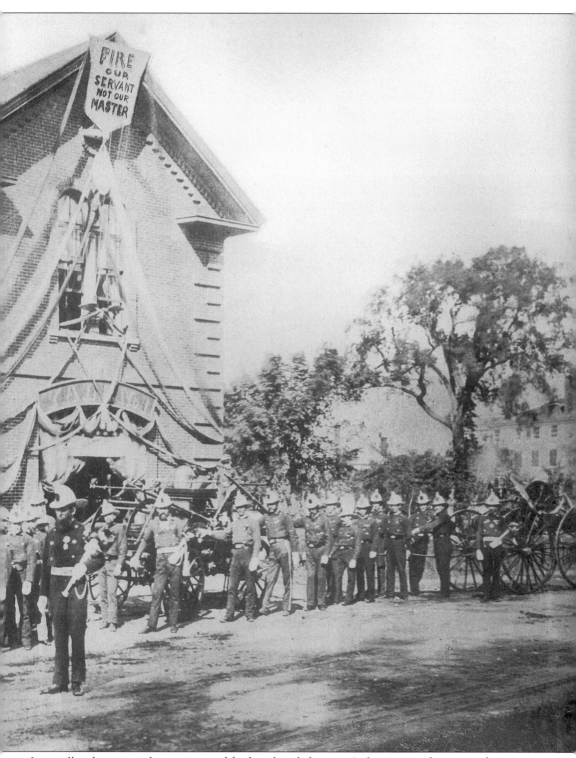

Ironically, the engine house pictured had replaced the town's first engine house on this site (constructed in 1852), which had burned in 1859.

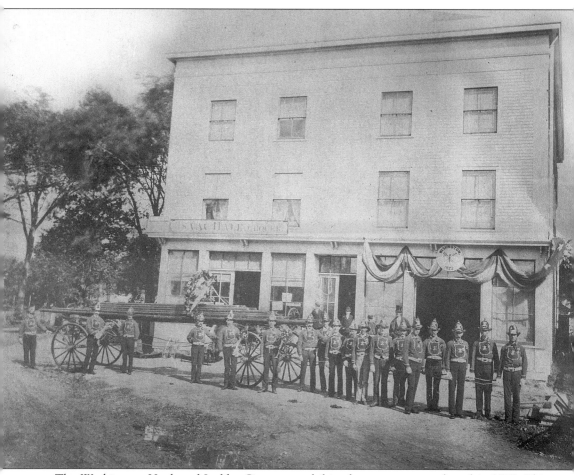

The Washington Hook and Ladder Company exhibits the apparatus purchased in 1871. This photograph was taken *c.* 1880 in front of the company's quarters in the old Town House building, which had been moved to the corner of Main and Salem Streets. The building bears a sign reading, "Isaac Hale, Grocer."

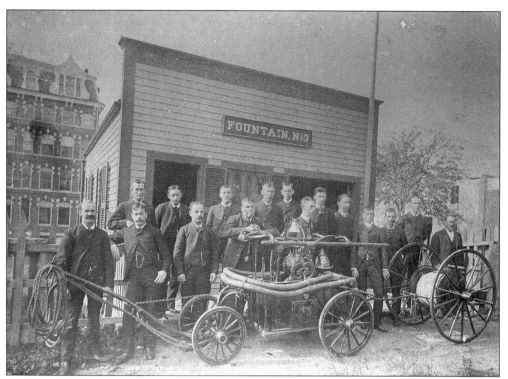

The members of Fountain No. 3 stand before their quarters on Crescent Street, at the corner of Lincoln Street, c. 1885. The hand tub was built c. 1835 by Increase Hill of Salem, Massachusetts.

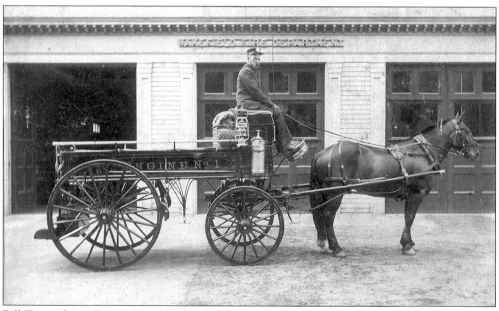

Bill Tyzzer drives Engine No. 1 in front of the wooden Central Fire Station on Crescent Street. The photograph shows one of the department's first horses, one of three purchased for the department in 1898. The fire station burned in 1899 and was replaced in 1900 by the present brick fire station.

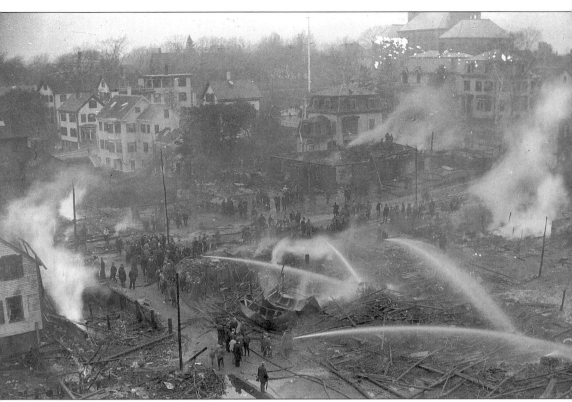

The Hathaway Stable was completely destroyed by a fire on October 23, 1899. Thirty-nine horses perished in the fire, which destroyed the stables on Mechanic Street (now Princess Street), the wooden Central Fire Station, and the town's old Central Schoolhouse, which had been moved from the Common. A total of 18 structures were destroyed in the fire.

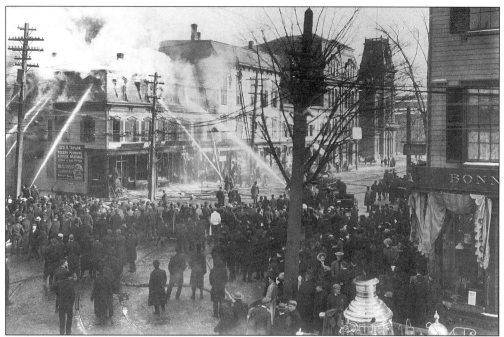

A fire at 446–454 Main Street (the Walton Block) caused $26,700 damage on March 5, 1907. This photograph was taken from the Bourdon Building. The Silsby Steamer, in the right foreground, failed to work at this fire. The fire, caused by fumes from a liquid dryer in contact with a gas jet, caused fire, smoke, and water damage to many tenants, including Taylor's Hardware, People's Clothing, and the Odd Fellows Hall.

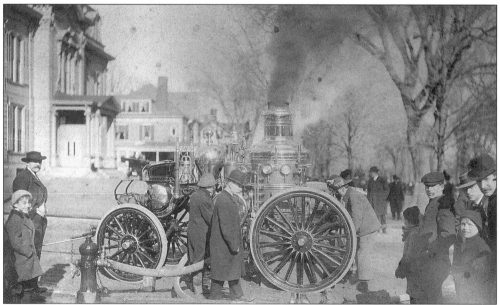

The 1907 Amoskeag Steamer is shown responding to the fire in the Congregational church in 1909. The steamer is shown in front of the high school on Lafayette Street. All Wakefield apparatus and companies responded to the fire. Mutual aid from other communities was not requested.

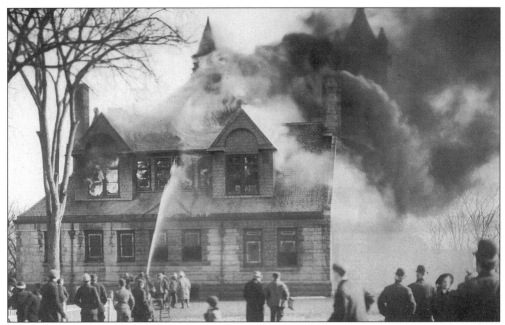

Fire caused almost complete destruction to the 1892 stone Congregational church (the congregation's fourth meetinghouse) on February 21, 1909. Immediate steps were taken to build a new meetinghouse on the ruins. The new church (still standing at lakeside) was dedicated in 1912.

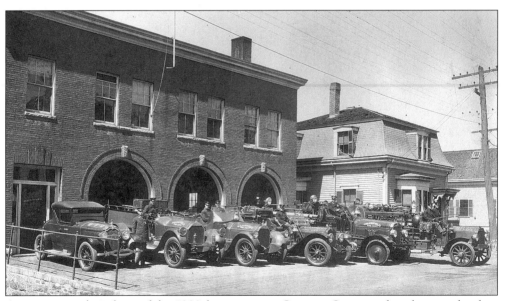

Apparatus stands in front of the 1900 fire station on Crescent Street in this photograph taken on October 5, 1929. The apparatus included the following: the 1924 Buick chief's car (Chief Fred Graham is pictured beside the vehicle), the 1920 Pierce Arrow Squad Wagon, Engine No. 2, the 1929 Seagrave 600-gallon-per-minute pumper, the 1927 Pierce Arrow reserve squad wagon, Combination No. 1, the 1918 White 1920 WFD chemical and hose wagon, Engine No. 1, the 1924 Seagrave 750-gallon-per-minute pumper, Ladder No. 1, and the 1924 Seagrave 75-foot aerial ladder.